close-up
photography
by
william j. owens

PETERSEN'S PHOTO PUBLISHING GROUP

PHOTO SPECIALTY PUBLICATIONS
Brent H. Salmon/Publisher
Paul R. Farber/Editorial Director
Mike Stensvold/Editor
Jim Creason/Art Director
Lynne Anderson/Managing Editor
Charlene Megowan/Assoc. Mng. Editor

PHOTOGRAPHIC MAGAZINE
Brent H. Salmon/Publisher
Paul R. Farber/Editor
Cliff Wynne/Art Director
Jim Cornfield/Feature Editor
Karen Sue Geller/Managing Editor
Mike Brenner/Technical Editor
Joan Yaritz/Associate Editor
Markene Kruse-Smith/Associate Editor
Natalie Carroll/Administrative Assistant
Kathy Philpott/Production Artist
Ben Helprin/Contributing Editor
Kalton C. Lahue/Contributing Editor
Steve Poster/Contributing Editor
Robert D. Routh/Contributing Editor
David Sutton/Contributing Editor
Parry C. Yob/Contributing Editor
M.A. Hadley/Far East Correspondent

PETERSEN PUBLISHING COMPANY
R. E. Petersen/Chairman of the Board
F. R. Waingrow/President
Robert E. Brown/Sr. V.P., Corporate Sales
Herb Metcalf/V.P., Circulation Director
Philip E. Trimbach/V.P., Finance
Al Isaacs/Director, Graphics
Bob D'Olivo/Director, Photography
Spencer Nilson/Director, Administrative Services
William Porter/Director, Single Copy Sales
Jack Thompson/Director, Subscription Sales
James J. Krenek/Director, Purchasing
Thomas R. Beck/Director, Production
Alan C. Hahn/Director, Market Development
Maria Cox/Manager, Data Processing Services

Library of Congress Catalog Card Number/74-31880
ISBN/0-8227-0094-8

COVER
Photo by Jim Cornfield;
design by Jim Creason.
Watch courtesy of Donavan
& Seamans Co., Los Angeles.

what is close-up photography?

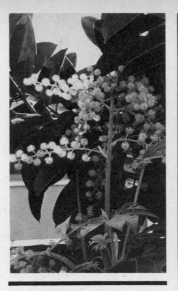

Close-up photography may be defined as taking pictures closer to the subject than is normally possible with your existing lenses. If your normal 50mm lens focuses down to 18 inches, any photos made with that lens in the area closer than 18 inches—say at 10 inches, or five—will be examples of close-up photography.

There are several ways to make photographs in the close-up realm—close-up lenses, extension tubes, bellows, macro lenses—and these will be discussed in the next several chapters. All of these devices let you focus closer than the closest focusing distance of your standard lenses. They do this in different ways; each has its advantages and disadvantages.

The techniques of close-up photography can be used to produce larger-than-life views of small objects, or detailed views of small parts of large objects. The techniques can also be used to produce abstract "what is it?" shots of common objects that we don't normally see the way the close-up photograph presents them. The applications of close-up photography are many and fascinating.

There are several terms that are applied (and misapplied) to close-up photography:

MICROPHOTOGRAPHY—First impressions on hearing this term usually conjure up thoughts of photography through a microscope, but microphotography really refers to reducing a large object to the size of the film frame—photographing a large object so that it fills the film frame. The microfilms of old newspapers you can get at libraries are examples of microphotography; spies photographing secret documents with their tiny spy cameras are another example of microphotography. Photographing an 8x10 print full-frame with a 35mm camera is microphotography. Copying a 35mm slide with a 35mm camera is just outside the limit of the term microphotography, since you are no longer reducing the size of the object to the size of the film frame; you are merely copying it life-size. Anytime you photograph something larger than the film frame you're using, reducing it to the size of the frame, you are doing microphotography.

MACROPHOTOGRAPHY—This term means making larger-than-life photographs. True macrophotography includes the making of giant-size pictures, such as murals. We could easily apply this to any enlargements. But in practice, this term has come to cover the area from life-size photography through larger magnifications up to

This book will tell you how to get from the closest focusing distance of your camera lens to frame-filling close-ups of up to about 5X life-size.

where a microscope is needed. Macrophotography makes use of the close-up equipment discussed in this book, and along with the closer range of microphotography, is what the book is all about.

PHOTOMACROGRAPHY—This is the accurate term to define the area described under *macrophotography*, and precision dictates that this term be used in what we commonly consider real close-up photography. However, if a photographer calls his work in this area macrophotography, we can understand what he is talking about. There appears to be some justification for the interchangeability of the terms. Since we are taking objects of less than frame

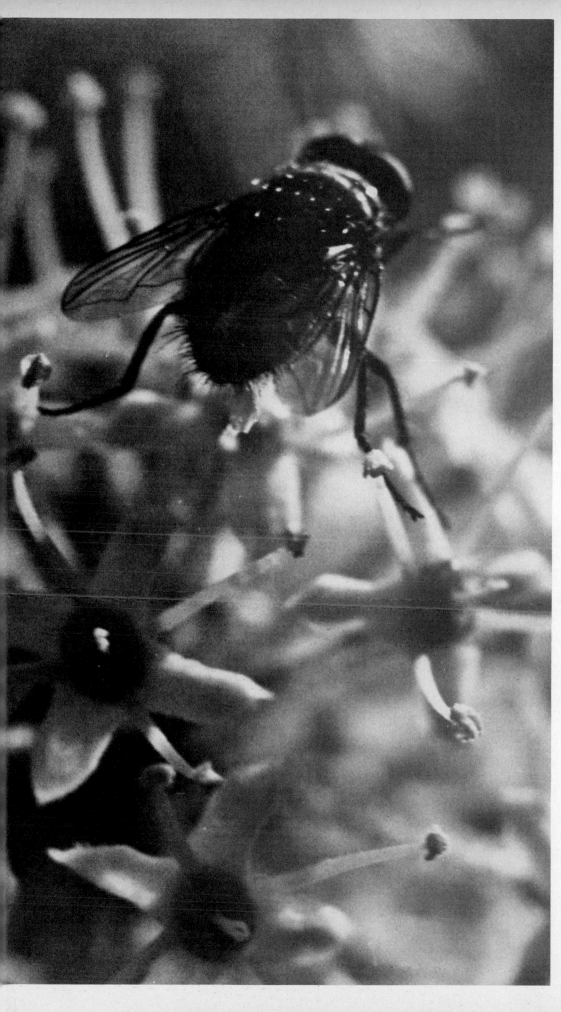

size and making them fill the frame, we are in actuality making an enlargement.

PHOTOMICROGRAPHY—This is the term used when the camera lens is replaced by a microscope optical system. This is not normally considered close-up photography in terms of the average photographer; it is ultraclose-up photography and requires a special treatment beyond the scope of this book.

What we will consider as close-up photography, then, and what we will cover in this book, is photography from the closest focusing distance of the standard camera lenses down to that which requires the use of a microscope. This area can be entered with readily available close-up equipment, with most cameras. It should be pointed out that a single-lens reflex camera with a meter that reads through the lens is by far the best camera for close-up photography, for reasons that will be discussed in the chapters on the various types of close-up equipment. Lacking this, other cameras may be used, but their usefulness is somewhat limited. Reference is generally made throughout the book to the use of a 35mm SLR, but the basic principles apply to other cameras, except as noted as each principle is stated.

Close-up photography offers a new way of looking at the world around us. An understanding of the basic concepts of close-up photography can be applied to general photography with resultant better pictures. □

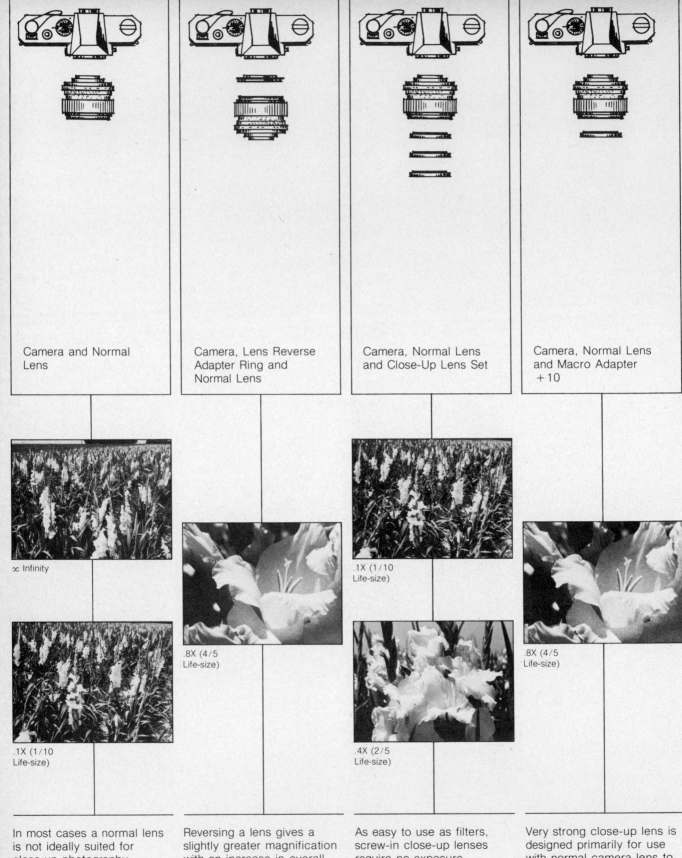

Camera and Normal Lens

∞ Infinity

.1X (1/10 Life-size)

Camera, Lens Reverse Adapter Ring and Normal Lens

.8X (4/5 Life-size)

Camera, Normal Lens and Close-Up Lens Set

.1X (1/10 Life-size)

.4X (2/5 Life-size)

Camera, Normal Lens and Macro Adapter + 10

.8X (4/5 Life-size)

In most cases a normal lens is not ideally suited for close-up photography. Special accessories must be added to extend the magnification range and enhance the overall picture quality at close-up distances.

Reversing a lens gives a slightly greater magnification with an increase in overall picture quality.

As easy to use as filters, screw-in close-up lenses require no exposure compensation.

Very strong close-up lens is designed primarily for use with normal camera lens to obtain close to life-size pictures.

Courtesy of Ponder & Best/Vivitar.

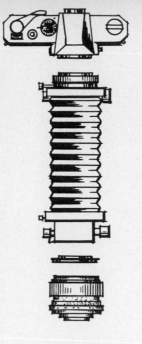

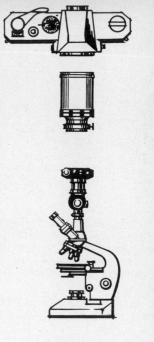

| Camera, Automatic Extension Tubes and Normal Lens | Camera, Bellows and Normal Lens | Camera, Bellows, Lens Reverse Adapter Ring and Normal Lens | Camera, Microscope Adapter and Microscope |

.5X (½ Life-size)

1X (Life-size)

1.5X (1½ Times Life-size)

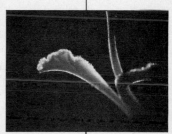

10X (10 Times Life-size)

1.75X (1¾ Times Life-size)

4.6X (4 3/5 Times Life-size)

5.5X (5½ Times Life-size)

Set of three tubes can be used in combination to provide magnifications up to greater than life-size.

Bellows lets you take pictures from life-size up to more than 4½ times life-size, is most versatile piece of close-up equipment.

Lens Reverse Adapter Ring allows use of normal camera lens on bellows for slightly greater magnification plus improved image quality.

Vivitar Microscope Adapter adapts virtually any 35mm SLR camera to microscopes using compatible T-mount system. Magnification is limited only by power of microscope lenses, and this is beyond the scope of this book.

close-up lenses

Without a doubt, the most convenient way to get into close-up photography is to use supplementary close-up lenses. These look like colorless filters at first glance, but actually are simple meniscus lenses similar to those used in eyeglasses to correct for farsightedness. They just screw onto the front of the camera lens and make it possible to focus on subjects nearer to the camera than would be possible with the camera lens alone.

If you are using a single-lens reflex camera, you can see through the lens just what you'll be putting on your film, so the SLR is by far the best way to go when using close-up lenses, as well as other close-up devices. The ability to see through the lens greatly simplifies producing sharp, properly framed photographs. Just screw the close-up lens onto the camera lens, put your eye to the viewfinder, and move the camera closer to or farther from the subject to change image size and focus.

Close-up lenses come in varying strengths. These strengths are expressed in *diopters,* and close-up lenses are generally available in strengths from +1 to +10 diopters. The larger the diopter rating of the close-up lens, the closer one can get to the subject.

The diopter rating of a lens is simply the reciprocal of its focal length in meters (its focal length in meters divided into one): a 50mm (.05m) focal-length lens has a diopter rating of 1/.05, or

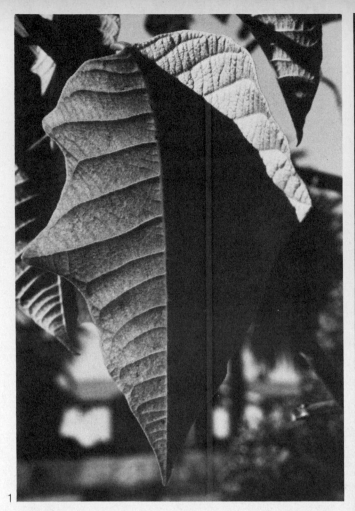

1

20 diopters. Knowing this, we can determine that the focal length of a +1 diopter close-up lens is one meter, or about 39 inches. The focal length of a +10 diopter close-up lens is 0.1 meter, or about four inches.

If the lens on the camera is focused at infinity and a close-up lens is attached to it, the combination will be focused at a distance equal to the focal length of the close-up lens, and this holds true regardless of the focal length of the camera lens. Thus, if we know the focal length of the close-up lens we're using, we know how far from the camera the subject must be in order to be in focus when the camera lens is set at infinity.

Close-up lens manufacturers provide fairly explicit charts of angles of

coverage and distance from front of lens to subject, and these can be quite useful for users of rangefinder cameras, who cannot see through the lens whether or not the subject is in focus. However, sometimes, due to manufacturing tolerances, a "+10" close-up lens will really be a +9.2 or something like that, and this can throw the charted

2

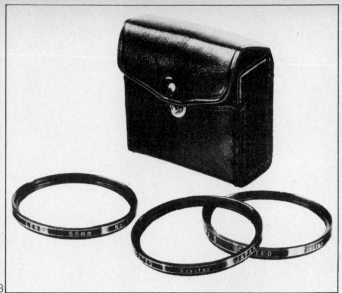

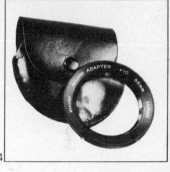

1. 2. Leaves make good subjects for close-up lenses. Try different angles to get different lighting effects.
3. Typical close-up lens set. such as this from Vivitar. consists of three screw-in lenses in strengths of +1. +2 and +3 diopters. is good first investment in close-up photo equipment.
4. Vivitar Macro Adapter +10 is strong close-up lens that produces 0.8X (almost life-size) image of subject.

figures off. It's a good idea, particularly in the stronger diopter strengths, to use this practical test to determine the actual focal length of your close-up lens: Just pretend the close-up lens is a magnifying glass, and focus the sun's rays on a nonflammable surface with it, as though trying to start a fire with a magnifying glass. Then measure the distance from the close-up lens to the point on the surface where the light's rays are focused, and that is the focal length of the close-up lens.

The focal length of the close-up lens represents the maximum working distance (distance from lens to subject) of the close-up lens/camera lens combination. By turning the camera lens's focusing ring to a nearer setting, it is possible to get closer to the subject. Again, if you are using an SLR, this is a snap; just look through the viewfinder and move the camera back and forth and turn the focusing ring until you see what you want. (If you have turned the focusing ring to its nearest setting and still are not close enough, then switch to a close-up lens with a higher diopter rating.) If you are using a rangefinder camera, you can still "focus down,"

1

2

1, 2. *Two-element close-up lenses like these from Minolta and Konica correct chromatic aberrations, are used just like single-element close-up lenses.*
3. *Flowers are good subjects for close-up lenses. Here, morning-glory was subject.*

but you'll have to use a bit of arithmetic as well. The formula is:

$$d = \frac{fl}{f + l}$$

where d is the actual distance focused on, f is the distance set on the focusing scale of the camera lens, and l is the focal length of the close-up lens. For example, if the focal length (l) of the close-up lens is 39 inches, and the camera lens is focused (f) at two feet (24 inches), the actual distance focused on will be 24 times

39 inches divided by 24 plus 39 inches, or 936 inches divided by 63 inches, or about 15 inches.

Especially when using a rangefinder camera, but preferably always, you should stop the lens down as far as possible to increase depth of field, as it will be extremely limited at such close focusing distances. Since you can't really see whether your focus is right on with a rangefinder camera, it's nice to have even that tiny bit of leeway afforded by stopping down the lens. With an SLR equipped with a depth-of-field preview, you can see just what's going on.

Stopping down the lens should present no problem, because close-up lenses don't require added exposure as do other close-up devices. Just determine your exposure in the usual manner, as though the close-up lens were not there.

You can combine close-up lenses to increase

magnification, but will suffer some loss in sharpness of the picture by doing so. If you do combine them, place the stronger (i.e., higher diopter number) lens on the camera lens first, then attach the weaker close-up lens to the stronger one.

Close-up lenses are the most convenient close-up devices, but they do have their drawbacks. There is a limit to how close they'll let you get. Distortion becomes a problem when using the stronger close-up lenses, especially when trying to photograph flat-field subjects (as when copying photographs). Actually, extension tubes, which utilize only the fine optics of the camera lens, provide better results, even within the range of magnification provided by close-up lenses. But close-up lenses are easy to use, and their results are acceptable for a lot of close-up work, so they have a place in your equipment bag, and you'll find them quite useful.

3

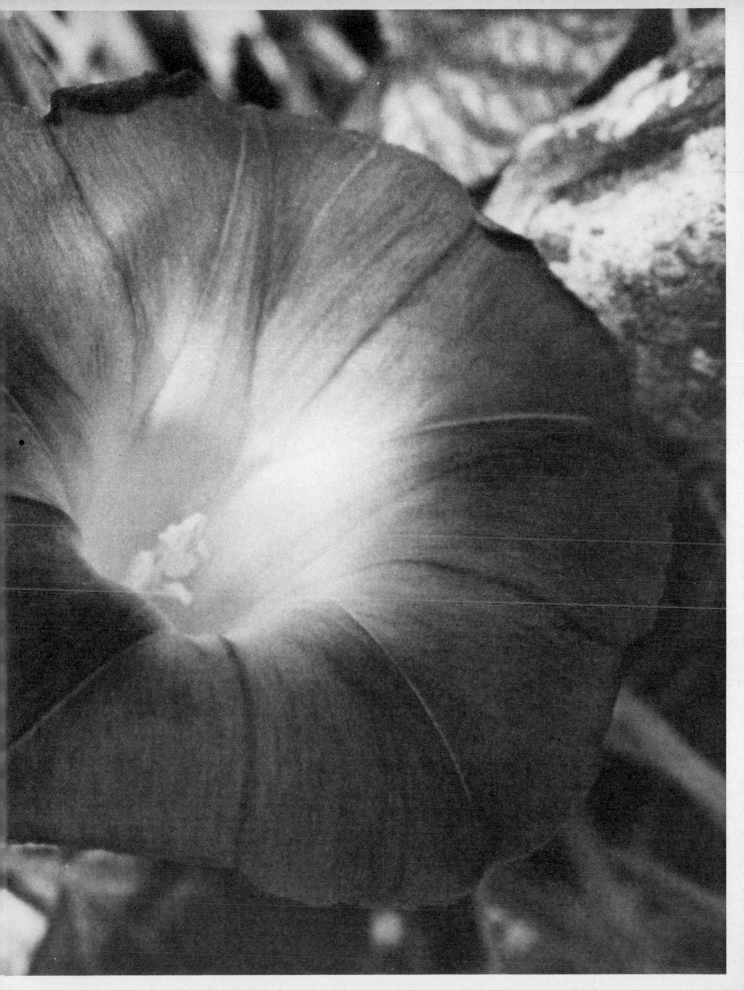

2

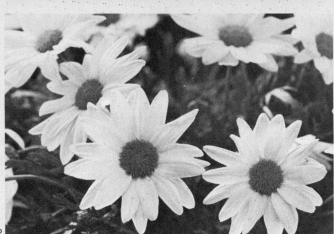

1

3

Flowers, coins, larger insects, birds (if you can get close enough), fish in aquariums, small animals and natural "found" objects (things like chipped paint, nails in wood, fence mesh and other things that take on an abstract appearance when photographed close-up) make good subject material for close-up lens work. In trying to follow the movement of small animals and insects, the camera is usually hand-held. In such work, it is suggested that a point of focus be set and not

1. Sequence, courtesy of Ponder & Best, shows comparison of various strengths of close-up lenses. This was shot with normal 50mm lens.
2. Normal camera lens and +1 close-up lens let you get this close to subject.
3. Normal 50mm lens and +2 close-up lens produced this shot of subject.
4. Normal camera lens and +3 (+1 and +2 lenses combined) close-up lenses get us still closer to subject.
5. Normal camera lens and +4 close-up lens provide this view of subject.
6. Normal camera lens and +4 and +1 close-up lenses move us in still closer.
7. Normal camera lens, +4 and +2 close-up lenses yield this shot of subject.
8. All three (+1, +2 and +4) close-up lenses on normal camera lens produced this close-up view of subject.

touched during shooting; instead, simply move the camera back and forth until the subject is sharp and then make the exposure. This technique is especially important if you are trying to achieve a particular reproduction ratio (magnification), for each time the focusing ring of the camera is moved, the reproduction ratio changes. It is a good idea to make more than one exposure when possible to increase the chances of getting a sharp picture, since focusing is so critical. It is also a good idea to use a tripod whenever possible.

Supplementary close-up lenses are supplied by most camera manufacturers, and because of their universal appeal and application, they are also manufactured by accessory suppliers; they are available in many sizes and strengths to fit many cameras.

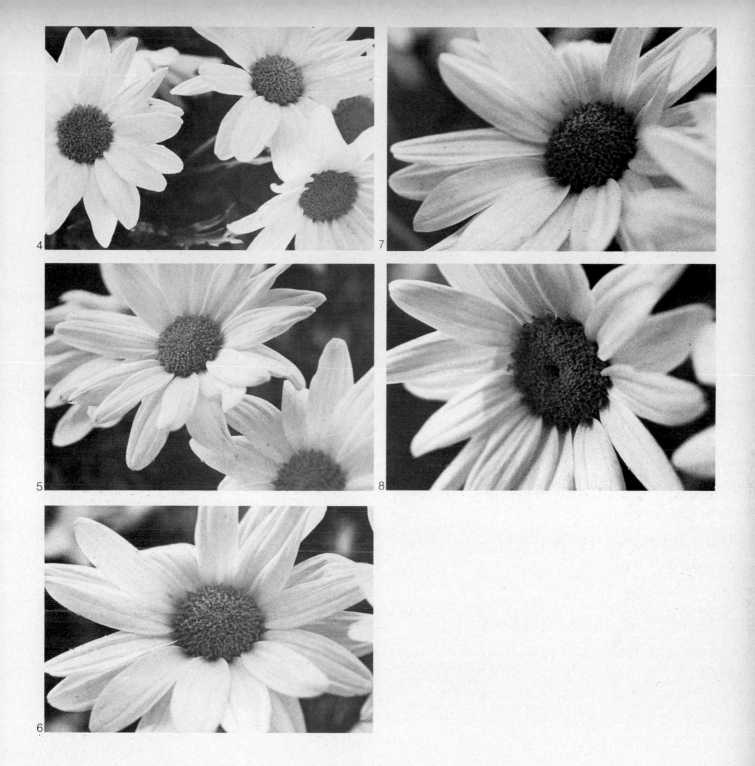

4

7

5

8

6

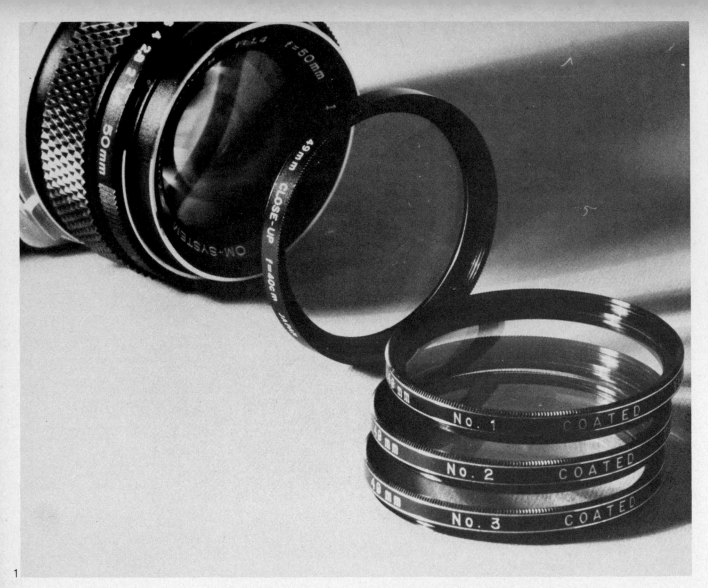

1

ONE LAST NOTE CON-
CERNING RANGEFINDER
CAMERA USERS—Once
you've determined the focal
length of your close-up lens,
and used the formula given if
you focus the camera lens
closer than infinity, you can
use the manufacturer's
charts and tables to provide
the area of coverage for
your setup, but you still will
have framing problems. You
might set up a large piece of
cardboard, with a cross
made of a couple of
yardsticks or tape measures
on it, and shoot a roll or two
of film with the close-up lens
in place, taking care to keep
the edges of the viewfinder
lined up with certain noted
inch marks on the
cardboard. Then, looking at
the negatives or slides, you
can perhaps correlate
viewfinder positions with
actual picture coverages,
using the inch marks on the
yardsticks or tape measures,
and make notes for future
close-up lens applications.
Or you could put the camera
on a tripod and try to
visually center the scene
vertically and horizontally. □

*1. When using close-up lenses
in combination, be sure to
attach strongest close-up
lens to camera lens, then
attach weaker close-up lenses
to the stronger one.*
*2. Close-up lenses can be
used in conjunction with
extension tubes for greater
magnification of image.*

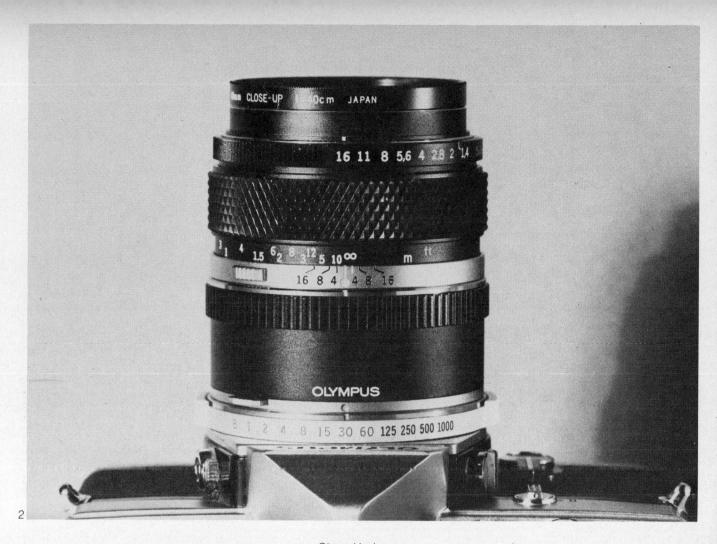

2

Close-Up Lenses

Diopters	Focal Length	Use on Lens No Longer Than	Reproduction Ratio with Various Lenses (at Infinity)						
			28mm	50mm	55mm	85mm	100mm	135mm	200mm
+1	1000mm	500mm	1:36	1:20	1:18	1:12	1:10	1:7.5	1:5
+2	500mm	250mm	1:18	1:10	1:9	1:6	1:5	1:3.7	1:2.5
+3	333mm	180mm	1:12	1:6.7	1:6	1:4	1:3.3	1:2.5	1:1.7
+4	250mm	125mm	1:9	1:5	1:4.5	1:3	1:2.5	1:1.9	
+5	200mm	100mm	1:7	1:4	1:4	1:2.4	1:2		
+6	166mm	85mm	1:6	1:3.4	1:3				
+7	143mm	75mm	1:5.5	1:2.9	1:2.7				
+8	125mm	65mm	1:4.5	1:2.5	1:2.3				
+10	100mm	50mm	1:3.5	1:2	1:2				
+20	50mm	50mm *	1.7:1	1:1	1:1.1				

* The +20 close-up lens is about as strong as is practical; results tend to be distorted. Rule of thumb: Close-up lens should not be used with camera lens that is more than half the focal length of the close-up lens.

For example, a +4 close-up lens has a focal length of 250mm; for best results, it should not be used on a camera lens longer than 125mm. Determining magnification is easily done by dividing the focal length of the close-up lens by the focal length of the camera lens being used. This will give you the approximate magnification when the camera lens is focused at infinity. Focusing the camera lens closer than infinity will result in slightly greater magnification.

extension tubes

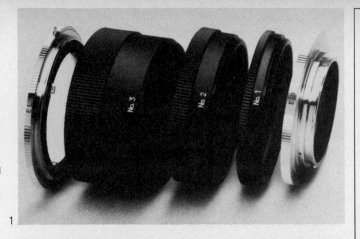

Using extension tubes eliminates many of the problems that go along with close-up lenses, such as distortion and flare. An extension tube is merely a spacing device, a hollow ring or tube. There is no lens in the tube to aid magnification. It is the extension of the distance between the camera and the lens that produces the increase in magnification. The standard set of extension tubes combines to produce about 50mm of extension between the camera and the lens; this amount of extension will produce a reproduction ratio of 1:1 (life-size) when a 50mm camera lens is used. (When the amount of extension equals the focal length of the lens in use, a 1:1 reproduction ratio will be the result.)

Since the extension tubes contain no lenses, your photos made with them will be as sharp as your camera lens will permit. And since there is no added lens element that is not in contact with the camera lens, as when using close-up lenses, flare is not a problem when using extension tubes.

Actually, any tube that can be attached to the camera and to the lens will work; an extension tube's purpose is to hold the lens a desired distance away from the camera and keep out extraneous light. Orange juice cans with their ends removed have been known to be fastened between camera and lens, with good results, but extension tubes made for your camera and lenses are far more

1

1. Extension tubes fit between lens and camera to extend distance between lens and film plane, and generally come in sets of several tubes. This Extension Tube II set from Minolta consists of three tubes and two rings of various lengths that can be arranged in eight different combinations to permit frame-filling close-ups of anything from pets to postage stamps.
2. Konica Auto Ring II with double cable release allows semi-automatic operation of Konica extension tubes similar to operation of "automatic" bellows units.
3. Extension tube sets from Vivitar fit several cameras.

2

convenient as well as more precise.

O.K., so extension tubes simply add light-tight space between the lens and the camera. How do we use them? Just put a set on the camera, and look through the viewfinder, assuming you have an SLR camera. The two main considerations when using extension tubes are focusing and exposure.

The standard focusing technique with extension tubes is to set the focus for a desired area of coverage, or reproduction ratio. This is done by looking through the viewfinder with the lens mounted on the tube(s) and seeing how much magnification is needed. Determining reproduction ratio involves comparing the size of the image to the size of the object. While it is an easy matter to measure a stamp or a coin, it is frequently difficult to measure a bee, bird or similar subject. Most of the information regarding areas of coverage and

reproduction ratios when using tubes of given lengths is included in the instructions for the tube sets.

When you extend the distance between the lens and the film plane (camera), you must increase the exposure. This is because the effective f-number of the lens becomes greater as the distance between the lens and film plane is increased. An f-number is the ratio between the size of the lens's diaphragm opening and the lens's focal length. A 50mm lens set at f/8 will

3

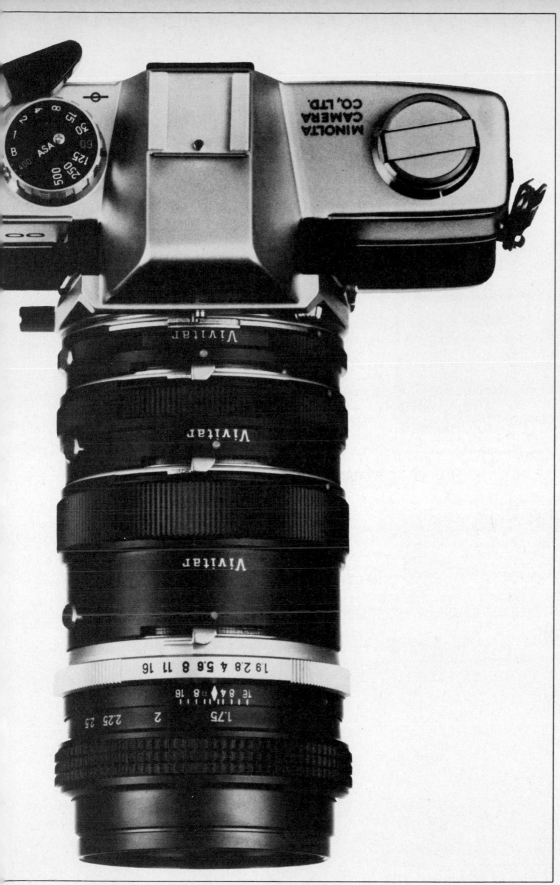

have an aperture diameter of ⅛ of 50mm, or 6.25mm. If 50mm of extension tubes are placed between the lens and the camera, the effective focal length of the lens is increased by 50mm, becoming 100mm. If the lens is set on f/8, the diameter of the aperture is still 6.25mm, but 6.25mm is 1/16 of the effective focal length of the lens/extension tube combination, so the effective f-stop of this combination is f/16. You'll have to open the lens up by two stops, or slow the shutter speed two steps, in order to get the equivalent of an f/8 exposure with the 50mm lens alone. (Actually, when you focus a camera lens from infinity to its closest focusing distance, the lens grows slightly longer, and therefore slightly more exposure will be needed, but this is a negligible effect for most purposes.)

If your camera has a light meter that reads through the lens, it will automatically compensate for the extension tubes. If not, you'll have to bear in mind the foregoing, that as more distance is placed between the camera and the lens, less light reaches the film. If you remember that an amount of extension equal to the focal length of the lens you are using will produce a 1:1 reproduction ratio and will cut the light down by two stops, you'll be on the right track. You can use the following formulas to calculate exposure when the amount of extension does not equal the focal length of the lens in use:

$$f = \frac{FL}{A}$$

where f is the effective f-stop of your lens/extension tube

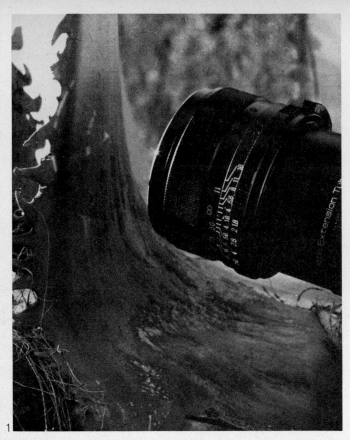

combination, FL is the effective focal length of the lens/extension tube combination (the focal length of the lens plus the amount of extension used), and A is the diameter of the aperture at which the lens is set. To determine the diameter of the aperture at which the lens is set, just divide the number at which the f-stop ring is set into the focal length of the lens.

A clarifying example: Let's say we are using 35mm of extension tubes with a 90mm lens, and our hand-held light meter says to shoot at 1/125 second at f/4. Now, the hand-held meter doesn't know we're using extension tubes, so its exposure recommendation must be adjusted. O.K., first we determine the diameter of

1. Extension tubes put 55mm lens in positon to shoot tooth edges of palm frond.
2. Varying lighting on palm frond gave teeth this appearance with extension tubes.

the aperture by dividing the f-number at which the lens is set into the focal length of the lens: $90 \div 4 = 22.5$. Next, we plug the numbers into our formula:

$$f = \frac{FL}{A}$$

$$f = \frac{35 + 90}{22.5}$$

$$f = \frac{125}{22.5}$$

$$f = 5.5$$

Our effective aperture with the lens set at f/4 is f/5.5, which is close enough to f/5.6 to be considered such for our purposes. In other words, we lose one stop of light with this extension

tube/lens combination. The light meter said 1/125 at f/4; we should open up one stop to f/2.8, or slow the shutter speed one step to 1/60 second and use the original f/4 stop.

If you have a meter that reads through the lens, and you are using a set of automatic extension tubes, you can use the meter just as you would for normal (nonclose-up) photography. If your extension tubes are not automatic, you'll have to use stop-down metering. If you have automatic lenses, they allow you to view the scene at the lens's maximum aperture, no matter what f-stop has been selected and set on the aperture ring. When the shutter button is pressed, the lens automatically stops down to the selected f-stop, the exposure is made, and the lens then opens back up to the maximum aperture. Automatic extension tubes couple up to the camera and lens's automatic linkage, and permit use of the automatic feature. Nonautomatic tubes do not couple up to the camera/lens automatic linkage. Therefore, when these are used, the lens actually stops down to whatever f-stop is set on the aperture ring; operation of the aperture ring actually reduces the amount of light seen in the viewfinder. The secret in working with this stop-down metering with nonautomatic tubes is to focus with the lens at maximum aperture, for the brightest image, then stop

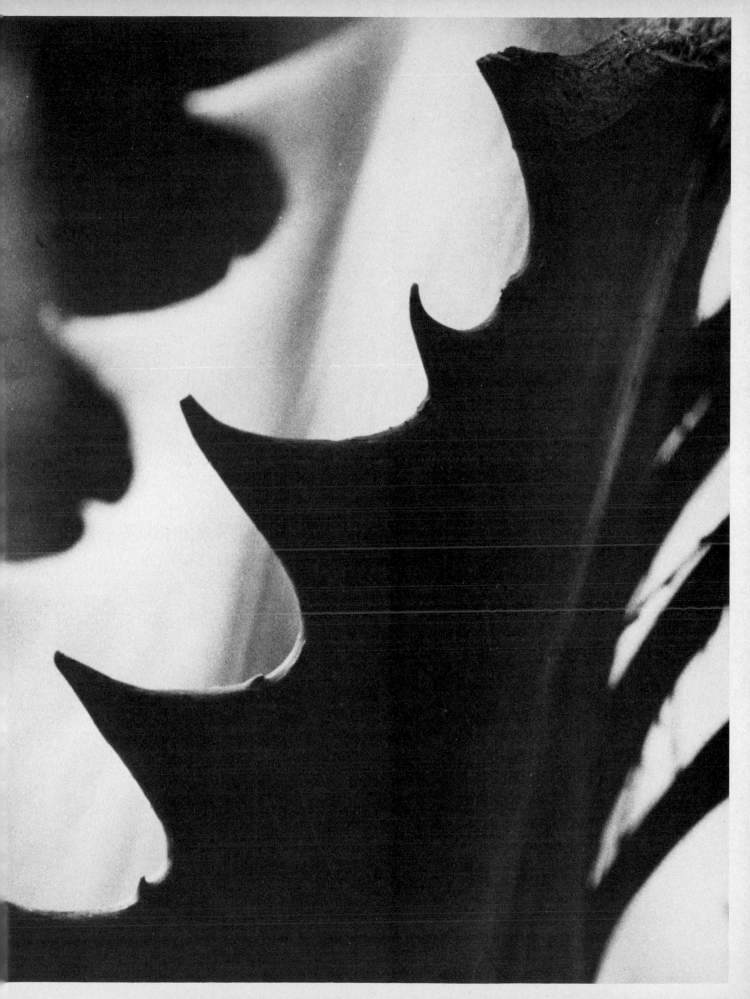

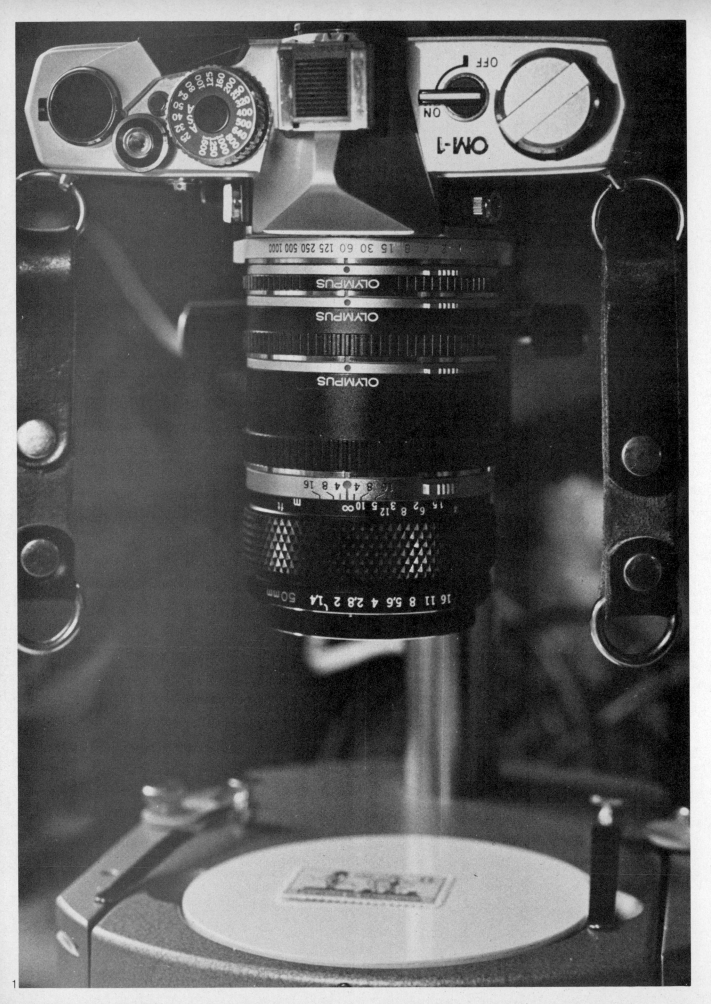

the lens down to the desired aperture; i.e., the one at which the meter needle centers, and make the exposure.

Less than a year ago, Ethan Winning of San Francisco bought a good quality SLR. I first met him as he was trying to obtain more information on close-up photography. He was trying to decide which equipment would be best for his needs; he was interested in nature photography. A number of his photographs appear in this book, which indicates that he quickly mastered the use of his basic equipment: extension tubes. At the moment his tools consist of a camera, several lenses, and an array of extension tubes: one 7mm tube, one 14mm tube and three 25mm tubes. If you think this means that you can use more than 50mm of tubes, you are absolutely right. But more of that later.

The array of tubes Winning uses adds up to 96mm, which at first thought might have indicated poor planning on the part of the manufacturer. Not so. Remember that as the focusing ring is moved from infinity to the closest focusing distance, the front of the lens moves away from the camera. On the normal 50mm lens, that distance is about 4mm. Ethan's favorite close-up lens is the 100mm camera lens. With the tubes and the focusing range of the lens, he can easily achieve 100mm of extension.

With the 96mm of extension possible with the tubes, and the added focusing distance of the lens, Winning obtains 100mm of extension. This gives him a 1:1 reproduction

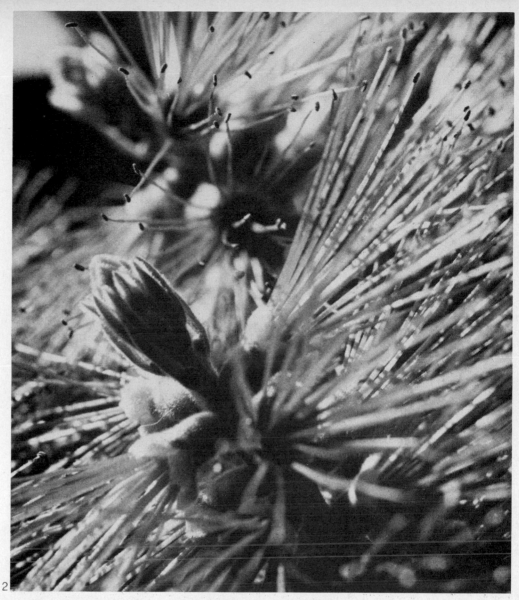

2

ratio. This is especially convenient, since he likes to photograph butterflies, bees and similar subjects in their natural setting. This focal length allows him to work a little further away from the subject and still get a good-size image. Sometimes it is desirable to work at even greater distances to avoid disturbing the subject. For example, in photographing snakes it is nice to think about using a 1000mm lens and 1000mm of extension. (As long as the amount of extension equals the focal length of the lens, the reproduction ratio will remain the same—1:1—but

1. Typical setup using extension tubes and macro stand is demonstrated by Olympus OM-1 system. Metering in such close-up work is critical, and excess light should not be allowed to enter through viewfinder, or erroneous reading will result.
2. Photograph of flower was made with 55mm lens and 25mm extension tube.

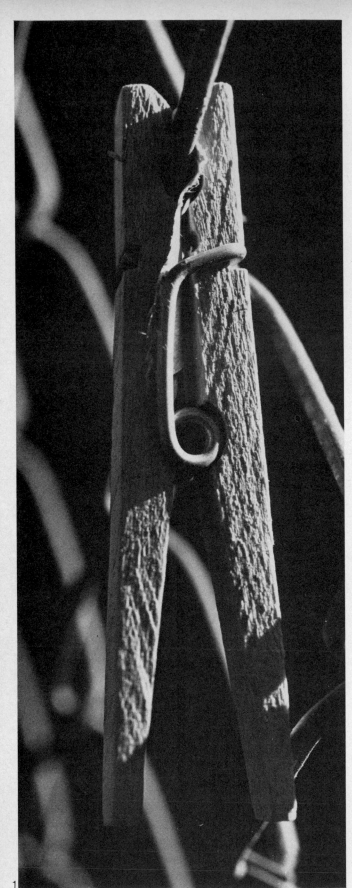

the working distance—the camera-to-subject distance—will increase as the focal length of the lens increases.) As stated before, any kind of tube could be used, even a pipe of the proper diameter.

This brings to mind an old story: A photographer attached his camera to one end of a 12-foot-long pipe and the lens to the other. His exposure worked out to be Saturday at f/8—the light loss is considerable at great extension distances.

Should the situation ever demand extreme extension, you just might be able to find a pipe of the proper diameter. This could be substantially less expensive than buying a great number of smaller extension tubes. It is conceivable that you could cement a short extension tube to one end of the pipe so that the camera could be attached, and another short tube could be cemented to the other end so that the lens could be mounted. Very little is impossible in photography. Several manufacturers have made tubes of great lengths available, but I know of very few that are available at this time. In practice there is little demand for such tubes, but some scientific applications might require them.

Extension tubes come in set lengths. To move from one reproduction ratio to another, in an effort to provide coverage at various distances, involves using the focusing ring of the camera

lens. It is possible to approximate every distance between the shortest tube and the overall length of the set being used by using the focusing ring. Precision is available if it is all that necessary. In most cases the objectives are to just provide a large image and come as close as possible to filling the frame.

If you use a precise extension tube to obtain a given effect or result, you can easily go back to that same setup again if you keep good records. It would be convenient to record not only the extension being used, but the distance setting on the lens, the f-stop and distance from the light to the subject. Results can be reproduced so far as the camera and equipment are concerned. Some applications would be in medical or scientific photography, where this exact information would make the results more valid or useful. □

1. A 50mm macro lens and 14mm of extension tubes recorded clothespin.
2. 50mm of extension tubes allowed 200mm lens to fill frame with blossoms.

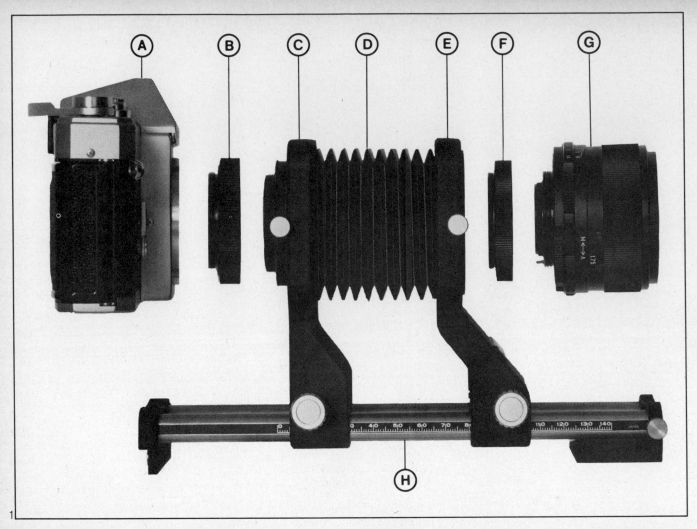

A B C D E F G H

bellows

Moving along in the realm of extension and into ultraclose-up photography leads us into the bellows. There is something about a bellows that seems to frighten the photographer the first time he sees one. It has an air of mystery, of the unknown. But without any hesitation at all I can say forget the fears and jump right in. Put the bellows on your camera and get to work. When you use the bellows you just get in closer to the subject. If you have had fun and good luck with close-up lenses and extension tubes, there is

nothing that can stop you from having fun and good luck with a bellows.

Just as extension tubes add space between the film-plane (camera) and the camera lens, so does the bellows. We can think of the bellows as a continuously variable extension tube.

The typical bellows has a standard to hold the camera and a standard to hold the lens. To keep these standards lined up, they are mounted on a rail along which they can be moved. Movement of the standards along the rail is easy, and most standards have devices such as set screws so that when a desired distance is found, they can be fixed in that position. Connecting the standards is a flexible bellows. The reason for the connecting bellows is to block off light, the same as the reason for the solid extension tubes. Most bellows manufacturers have

added other devices to make their use more convenient, such as a scale (usually in millimeters) so that a desired extension distance can be readily set during use. A few have front lens standards that can be moved or tilted for special, more advanced applications.

The bellows starts where the usual extension tube set leaves off; that is, at about a 1:1 (life-size) reproduction ratio. We can generally obtain larger images through greater magnification by using a bellows. The largest magnification possible on most bellows, assuming use of the normal 50mm lens in normal position, is roughly 4X. An object ¼-inch in size could be enlarged to fill the one-inch dimension of the

1. Exploded view of Vivitar bellows setup shows parts: A—camera body; B—adapter ring to connect camera and bellows; C—camera standard; D—flexible bellows; E—lens standard; F—adapter ring to connect bellows and lens; G—lens; H—bellows focusing rail (calibrated).
2. Olympus OM-1 system shows all parts hooked up for use. Lever A is used to stop lens down for depth of field preview, also to manually stop lens down for metering and shooting if double cable release is not used. Camera or lens standard is moved to provide larger or smaller image. If unit is mounted on tripod, knob B is used to focus; if unit is hand-held (not recommended), just move whole unit back and forth until image is in sharp focus.
3. Soligor Multiflex Auto Bellows fits several cameras, uses double cable release, is shown with slide copier attachment in place. Lens fits between bellows and slide copier.

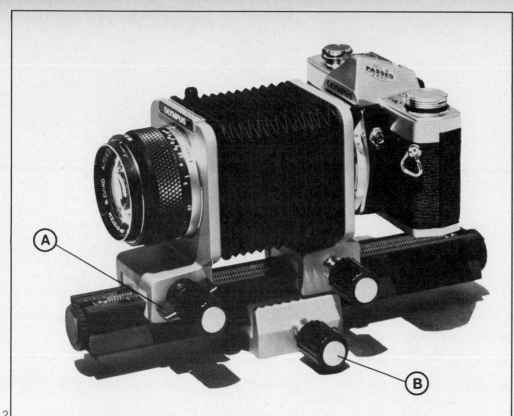

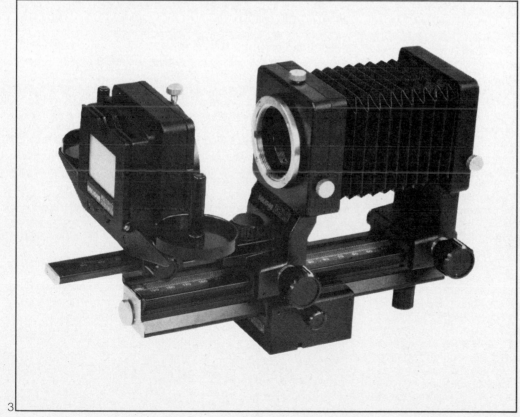

35mm frame in the camera. For exact specifications, consult manufacturers' literature and information sheets.

Many bellows distributed by camera manufacturers are called automatic bellows. This is somewhat of a misnomer, as no bellows to my knowledge is fully automatic so far as full-aperture viewing and metering are concerned. There are no linkages that permit the diaphragm of the lens to be stopped down at the instant of exposure. "Automatic" bellows generally require the use of a special double cable release to simultaneously trip the shutter and stop the lens down to the desired f-stop. If that is automatic, so be it. Actually, to determine the exposure when using a bellows between the camera and lens, it is necessary to use stop-down metering techniques. That is, the camera must be programmed for stop-down metering, the meter needle is lined up or matched as the aperture ring is turned while it actually closes down the diaphragm. In other words, the amount of light entering the system is reduced, causing movement of the meter needle—this because the automatic, full-aperture metering linkage between lens and camera is broken by the bellows. Some bellows lens standards have mechanisms that then allow you to open up the lens to maximum aperture for viewing and focusing, even while the f-stop ring is left at the determined f-stop. By using the double cable release the lens is stopped down to that desired f-stop a moment before the shutter is tripped. If you don't have a double cable release, or have misplaced the one you have, you can make the adjustment on the lens standard that stops the lens down to the desired aperture. In practice this presents no real problem.

If your camera does not have a meter that reads through the lens, you'll have

to calculate your exposure, taking into consideration the light loss caused by the extension. The amount of extension can be measured or read off the scale on the focusing rail. The necessary formulas and explanation are included in the chapter on extension tubes; the exposure compensation principles are the same for extension tubes and bellows.

Most camera manufacturers have bellows available. Some offer a wide range of accessories for technical work, while some bellows are simple for ordinary use. Many accessory manufacturers offer simple bellows that are less expensive than original-equipment bellows. If you plan to do a lot of bellows work, then buy the best, most rigid and versatile bellows you can afford.

Most camera manufacturers design their bellows systems to work only with their camera. Systems such as that made available by Soligor and Vivitar can be adapted to work with a greater variety of cameras. Adapter mounts are available to accept most of the popular cameras when using a universal independently made bellows. Widely available ''T'' mounts are used to mount the camera on the camera standard. A variety of camera lens mounts are available to fit

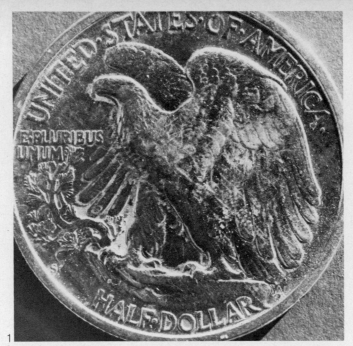

1. 2. *Bellows allows wide range of magnification, as shown by close-up of lower section of eagle's left wing on 50-cent piece.*

the camera lens to the lens standard.

Perhaps one of the most useful lens mounts is the Leica thread mount. This allows all lenses with Leica threads to be used, and this includes not only a large number of older Leica lenses, but especially a wide variety of flat-field enlarging lenses, allowing the purchase and use of relatively inexpensive lenses of many different focal lengths, lenses particularly useful in close-up work.

BELLOWS ACCESSORIES

I feel strongly that regardless of what bellows is purchased, it should be able to accept a slide copier attachment. Copying transparencies is one of the more interesting applications of the bellows, and an excellent reason for getting into bellows work in the first place. Most bellows will accept a slide copier designed for use only with

that bellows. Hence, it is not possible to use a Canon bellows with a Nikon slide copier. In fact, when a camera manufacturer has several bellows in its line, it is not always possible to interchange slide copiers and bellows. Be sure they fit together before you purchase them.

Most manufacturers have available a reversing ring, which enables you to turn the lens around on the bellows. This will provide additional magnification without increasing the

extension, a real plus in keeping exposures within a workable range. To give you some idea of what happens, Nikon has a BR-2 ring that screws into the accessory threads on the front of the lens. The other side of the BR-2 ring is the standard Nikon bayonet lens mount. With the normal 50mm lens, the usual closest focusing distance is 18 inches. When the lens is reversed with the BR-2 ring, the lens can be used to obtain nearly a 1:1 reproduction ratio. The reversing ring is designed for close-up work, so don't expect the lens thus reversed to focus at infinity.

Some reversing rings can be used to attach the camera directly to the lens. In the Vivitar bellows system, the reversing ring can be attached only to the bellows. The reversing ring is a most useful, frequently necessary accessory.

If the bellows you desire does not have a focusing rail, then consider purchasing one. As the bellows is best used on a tripod, a focusing rail is all but essential. Consider the fact that the magnification in bellows use is determined by the extension between the camera and lens. If this distance is changed, the magnification is changed. With a given amount of extension and magnification, there is only one point of focus. The focusing rail enables movement of the entire bellows system when it is mounted on a tripod or some other stand.

The macrophotographic stand has gained in popularity in recent years. Simply stated, it is a platform

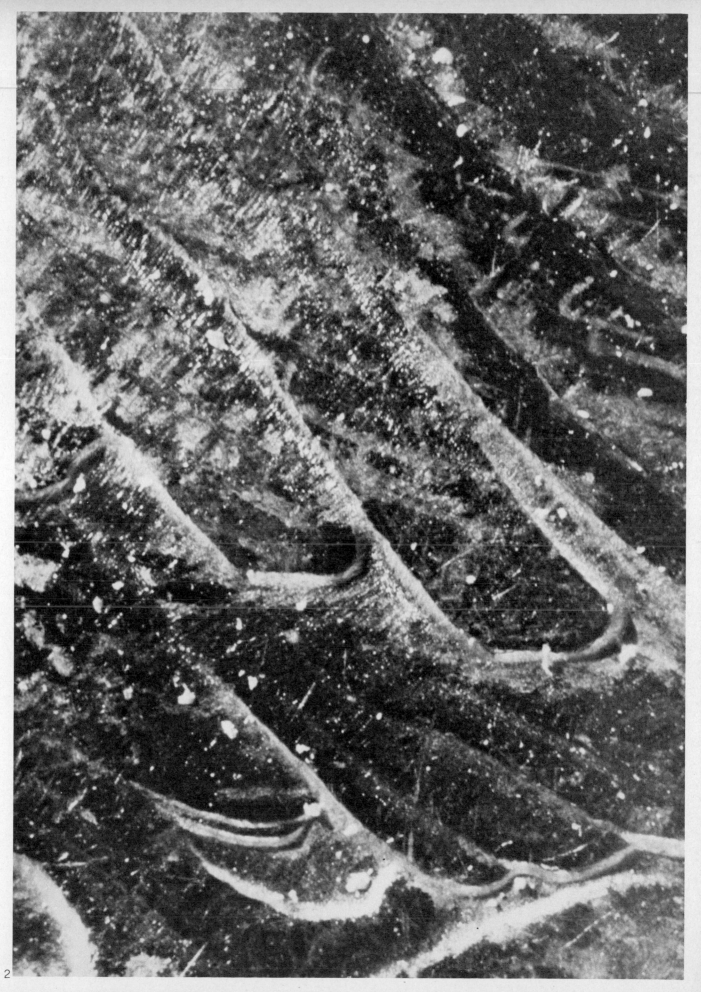

2

that can be attached to the bellows to hold small objects in place while they are being photographed. Most have interchangeable plates (specimen plates to the ardent user), one of which is solid and of a neutral color, the other of a translucent material to enable backlighting. As indicated in the lighting section, when the lens is close to the subject, lighting from the direction of the camera (front lighting) becomes difficult. Some subjects simply have to be lighted from behind, Macro stands usually have spring clips to hold the object in position. Because the macro stand is attached to the bellows, it is possible to use slower shutter speeds, as the chance of object movement is all but eliminated.

There are other accessories, but those mentioned are the more important ones. Having all of these will permit the photographer virtually all of the versatility that he will need in photomacrography.

USING THE SYSTEM

Once the camera and lens are attached to the bellows, we are ready to start. The standards in their closest position will separate the camera and lens by approximately 50mm. With the 50mm lens this will give us a 1:1 reproduction ratio. This will be a good point to make our first picture. Keeping the bellows standards in this position, look around for a suitable subject. Looking through the viewfinder, move the entire system back and forth until the subject is in focus. Take a meter reading, and make the exposure. That is all there is to making pictures with a bellows.

If you want more magnification in order to photograph smaller objects and still fill up the frame, increase the extension. At least in the beginning, it

Bellows allows small objects or portions of larger ones to be blown-up for study.

might be wise to leave the camera standard fixed in the rearmost position, and move only the front (lens) standard to increase extension and magnification. If you find that the length of the rail gets in the way and keeps you from getting close to an object,

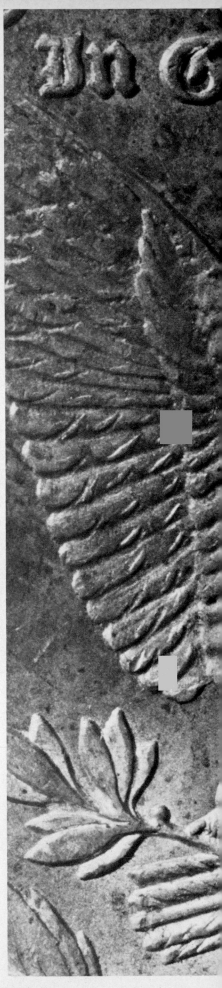

then move the front standard out to the front and leave it in a fixed position while you move the rear standard to increase the extension and magnification.

With the length of most rails, and the lens in the forward position, you can obtain about a 4:1 reproduction ratio (4X magnification) when the bellows is fully extended. This gives you the range, continuously, from a 1:1 to a 4:1 reproduction ratio. In many cases, reversing the lens by using the reversing ring discussed earlier will increase this range to 5:1 (5X magnification). Again, this assumes a 50mm lens.

Experiment with changing the image size by increasing or decreasing the extension. You will see the image size change in the viewfinder as you change magnification.

Changing the extension will change the exposure. An increase in extension (and magnification) will also increase the exposure. With a 50mm lens, each additional 25mm of extension will require opening the aperture about one additional stop. A built-in light meter that reads through the lens will make the required adjustments automatically.

A tripod is advised for holding the camera steady. Hand-holding a bellows with camera and lens attached is difficult. At full extension, shutter speed is likely to be slower than recommended for successful hand-holding of the system, particularly since we would like to use as small an f-stop as we can to obtain maximum depth of field. Once we have decided on an f-stop, we can make

exposure adjustments by changing the shutter speeds.

LENSES

The example just given assumes use of the normal 50mm lens. At first glance it may seem odd that if we were to now take off the 50mm lens and put on a 28mm lens we would significantly increase the magnification with the same amount of extension. Remember that with a 50mm lens and 50mm of extension, we come up with a 1:1 reproduction ratio. If we use a 28mm lens with that same 50mm of extension, we will come up with about a 1.8:1 reproduction, nearly 2X magnification. We will have to be much closer to the subject, but that is certainly workable in many cases. With 200mm of extension and the same 28mm lens, the magnification will be a little more than 7X, giving a reproduction ratio of 7.1:1.

A quick, simple way to determine the magnification is to divide the focal length of the lens into the extension used (in the previous example, 28mm goes into 200mm of extension 7.1 times). Yes, this rule is equally applicable to extension tubes or any other device that will provide extension between camera and lens.

Many manufacturers make bellows lenses, designed especially for use on the bellows. These are usually in the 100mm range. With a normal 100mm lens and 100mm of extension, we will have a reproduction ratio of 1:1. A bellows lens of 100mm differs in that, since it does not have a focusing mount, the space usually given over to the mount must be compensated for by bellows extension. Just for the 100mm bellows lens to focus at infinity, it will need enough extension to fill out a full 100mm. Another 100mm of extension would then be necessary to achieve a 1:1 reproduction ratio.

Lenses used with the bellows should be stopped down, preferably to at least

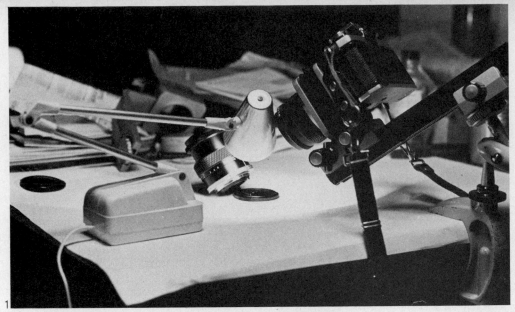

1

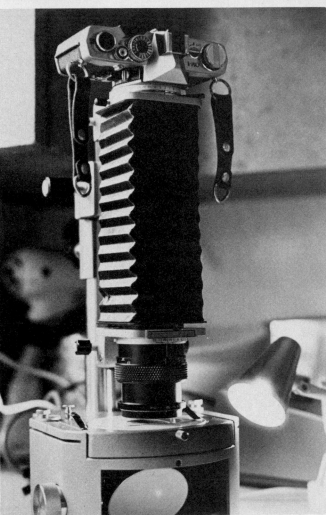

2

1. Example of bellows in use shows one possible setup. Bellows is attached to clamp-pod, which holds it firmly on table. Small. convenient high-intensity lamp provides illumination. Subject is scales on lens barrel.
2. Yes. you will sometimes get this close with bellows! Note position of light source to provide cross-lighting. Subject is stamp on macro stand designed for scientific close-up work.
3. Vivitar macro stand attaches to bellows and holds small subjects in position. greatly reduces chance of subject motion.
4. Miranda copy stand provides convenient way of getting bellows. subject and lighting together.

f/8. As the lens gets closer to the subject, f/11 and f/16 make more sense. The depth of field is extremely shallow at great magnifications.

Magnification is limited by the extension of the bellows and by the focal length of the lens. The shorter the lens focal length, the greater the magnification with any given bellows, and conversely, the longer the focal length of the lens, the less the magnification on the same bellows.

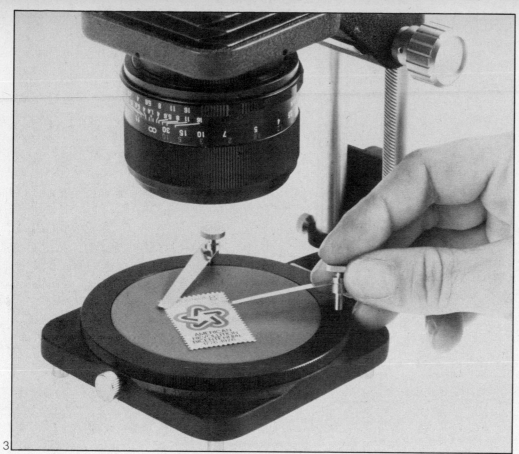

Reversing the lens helps but is not a complete solution. Flat-field lenses work exceptionally well. Fast, high-speed camera lenses make particularly poor ultraclose-up lenses. Any of the aberrations that are acceptable in regular work usually become glaring handicaps at great magnifications. Likewise, you would hardly expect a flat-field lens to perform well in normal-range photography, as it was not intended for that purpose.

Bellows can be linked together, most easily with extension tubes between them, but this isn't within the realm of casual close-up photography, or the scope of this book.

REVIEW

Extension tubes put a fixed distance (extension) between the camera and lens. Bellows units allow this distance to be varied. Putting distance between the camera and lens increases the magnification, allows us to focus on closer subjects, and requires more exposure. The greater the extension, the greater the magnification, the closer we can focus, and the more the exposure required.

With a given amount of extension, the shorter the focal length of the lens used, the greater the magnification, and the less the working distance (distance between lens and subject). If we want a greater working distance, we should use a longer focal length lens.

A 1:1 reproduction ratio (life-size image) is achieved when the amount of extension used equals the focal length of the lens used. □

One way to get around this and get greater magnification is to use extension tubes on the bellows. This will get more magnification, but the untimate usefulness will more and more depend on the quality of the lens. As discussed elsewhere, most camera lenses are designed for normal-range photography and perform less and less well as magnification increases.

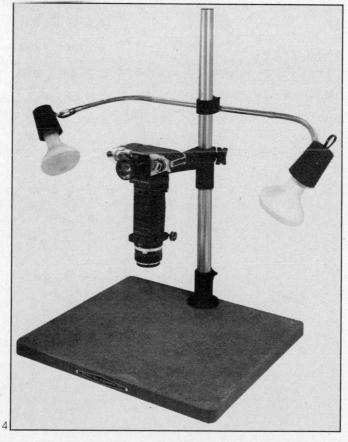

tips from a close-up bug

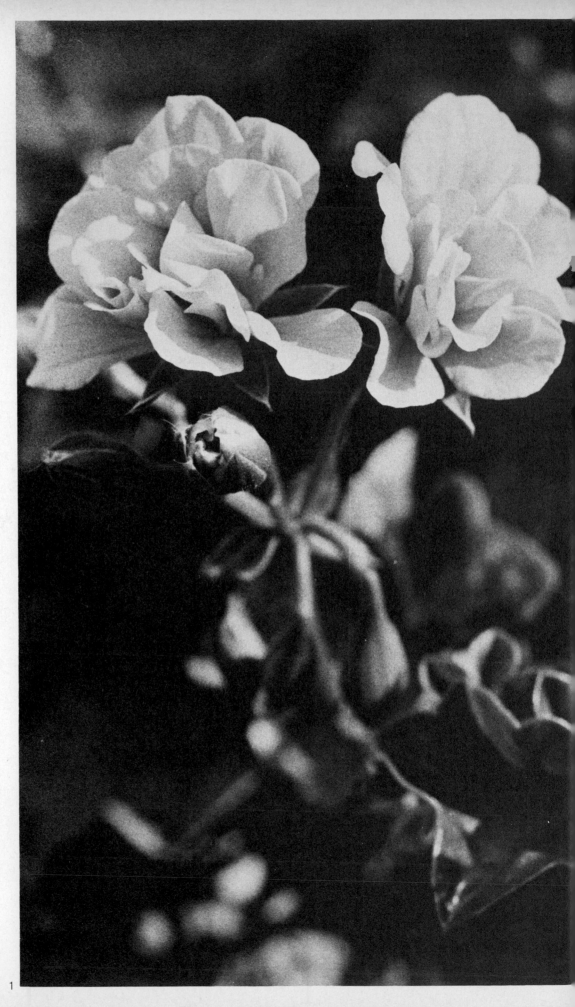

Business consultant Ethan Winning hasn't been into close-up photography for very long, but he's *really* been into it, and his ideas on the subject might be of some use to budding close-up photographers everywhere. So one day, when he emerged from a telephone booth transformed from Ethan Winning, business consultant, to Ethan Winning, close-up photographer, clad in old clothes, ready for the field with eyes darting around looking for subjects, eager hands moving fondly over neck-suspended cameras with lenses and extension tubes, I prevailed upon him to tell us what it's like:

"It has been said that close-up photography is one of the most demanding and frustrating of photographic pursuits, and unless you have a myriad of equipment and 10 hands to operate it, the amateur would best be suited to some other endeavor. Well, I disagree; I don't believe that a lot of expensive equipment is necessary or that the amateur should not try close-ups if he has an interest. The only prerequisite that I have is that he have a single-lens reflex camera.

"It is true that close-up photography is demanding. It requires patience and, if you are about to enter the world of smaller life, especially

2

*1. 3. Greatest appeal of
flowers is color. Black-
and-white demands a fresh
approach to overcome this
natural handicap. White
blossoms are all but lost in
overview at right. Moving
in close and isolating the
blossoms against a darker
background helps (left).
2. Ethan Winning is a rela-
tive newcomer to close-up
photography. but he has some
good advice for those
interested in the topic.*

insects and small flowers, it
may also be physically
demanding. I have hiked
miles in search of various
insects, have run with full
camera equipment and back
pack after an elusive
butterfly, climbed hills,
sloshed through mud, and
been caught in tidal surges
when trying to get shots of
birds. And 95 percent of the
time, my quarry eludes me.

But the results I do get make
it all worthwhile.

"The techniques I have
developed as a result of my
experiences and the
principles I follow allow for
limitations in equipment and
my own physical stamina,
and, most importantly, have
made the hobby of close-up
photography more enjoyable
and less frustrating.

"The tenets of my
philosophy are (1) know
your equipment and keep it
at a minimum; (2) know your
limitations as well; (3) know
your subject matter; (4) keep
your eyes open and have
patience; (5) use plenty of
film; and (6) remember that
luck plays a part and you
can do something to put the
odds in your favor.

"After years of carrying
the full complement of
equipment—all the lenses,
plus supplementary lenses,
right-angle finder, filters and
two tripods, along with a
strobe once in a while—I
streamlined. Now I carry two
cameras, one with a 100mm
lens, the other with a zoom
lens. The 100mm lens plus
96mm in extension tubes are
for photos of insects and
smaller animals and flowers,
while the zoom is for birds
and larger quarry. A
polarizing filter is also
included.

"Why extension tubes?
They are less cumbersome
than a bellows, and with a
steady hand can be used
effectively for anything from
½X to almost 2X
magnification. Extension
tubes (a set of one 7mm,
one 14mm and three 25mm)
cost one-quarter of what a
prime macro lens does. If
you are out to take
close-ups professionally,
then by all means obtain a
macro. If you are a
perfectionist, get a macro.
The only reason I do not
have one is financial.

"What is the best time to
photograph, say, insects? If

3

you can answer that
question, then you know
something about your
quarry, and that is one of
the secrets of success. (The
best time of year is early
spring, for that is when most
insects are just hatching or
recently hatched and move
slowly. The larger animals
are just coming out of
hibernation and react in
similar ways. On a recent
field trip I was able to take
20 pictures of bees on
various flowers in less than
half an hour! Many were
simply resting on a flower.)

"I have had an interest in
nature photography and
nature in general since I was

a biology major in college,
but one does not have to
have that background to
understand animals, to find
out when and where they
can be located. A recent
book called *Who Wakes the
Groundhog?* was a great
help to me, and, in fact,
gave me the answer to the
question about when to
photograph insects. Also,
state and regional parks
usually have some literature
on the wildlife in the region.

"It helps to know the
habits of the animals you're
about to photograph. It can
make the difference between
many trials and errors and
finding what you are looking
for on the first outing. If you
do not have this inclination, I
suggest sticking to larger
subjects and visiting the
local zoo. Some of my best

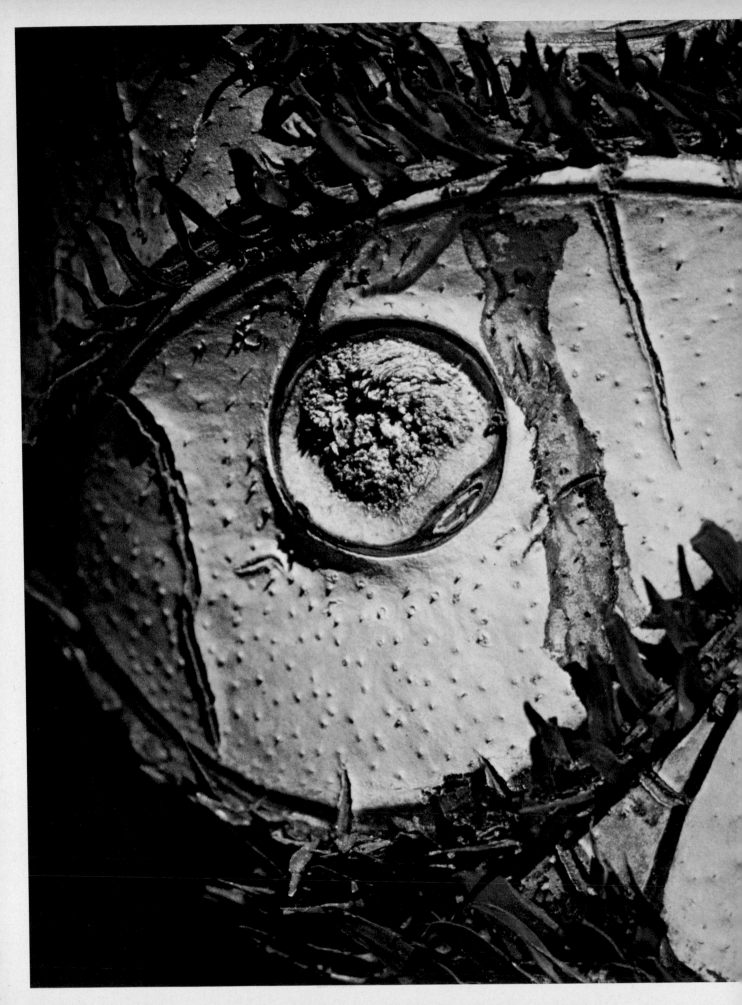

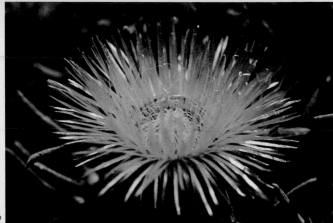

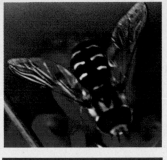

1. Frond was cut away from palm tree, and resulting eye-like effect was recorded with 200mm lens and 50mm of extension tubes. Close-up techniques can produce many fascinating abstracts.
2. Polarizing filter and 55mm macro lens combined to produce this photograph of yellow flower. Polarizer reduces reflections.
3. A 50mm lens on bellows set for 1X magnification was used to get close to center portion of bird-of-paradise flower blossom.
4. Bee working his flower route was captured with 50mm lens and 100mm of extension tubes for magnification.

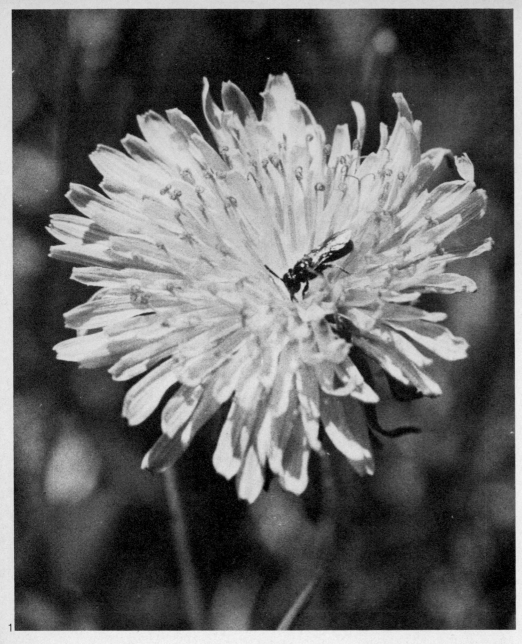

one feeder. Starting out at 7 a.m., I moved closer and closer to the feeder until I was certain that the hummer would accept my being there. Not only did he accept my presence and that of the camera, he came to investigate. Peering directly into the lens from no more than five inches away, he paused and gave me the perfect opportunity. Except that the camera was on a tripod and focused at around three feet and I didn't have a chance of refocusing. Three days in the broiling sun, 110 shots, and some very tired feet later, I had four fairly good pictures to show for my efforts. If you want to get into this type of photography, patience and the ability to accept such things are absolute musts.

"In close-up photography, don't be afraid to shoot a lot of film. With the lighting and depth-of-field problems and the ill cooperation of most subjects, expenditure of film is required. I have seen people willing to spend a small fortune on equipment and then skimp on a picture that will cost them 13 cents.

"For years I took many pictures, most of which I have not viewed since. They are not all that good. Had I taken more time and the 'more than one shot' approach, I would probably still be enjoying them. Now, for every roll of film expended, I average at least two good pictures. As long as I enjoy those two pictures, it's worth it.

"After all is said and done, there is no discounting of luck, pure and simple. There is luck involved in having the right lens or combination of lenses on the camera when you need them. Luck is certainly involved in finding what you are after in the right conditions. There is luck in focusing. But even though luck plays an important role in close-up photography, one should never have to say, 'I should have' If you say that, then your bad luck was more than luck.

"Oh, yes, good luck." □

pictures have been taken in zoos throughout the state of California. But, even in zoos I find it best to know something about the animals, for their behavior is not exactly predictable. I might also add that almost half of the pictures I have taken at zoos have been of insects, flowers and birds that are not in captivity.

"Patience is truly a virtue in close-up work. Don't expect that an animal will come to you and pose for your camera (in six settings with the right background and lighting), or that a

1. Shooting animal life of any kind requires a great deal of patience. and getting out in the field.
2. You don't need bellows for all subjects. Close-up lens was enough for these dandelion tufts.

butterfly will sit still for any length of time. And no matter how patient you are, expect a few setbacks.

"I spent three days trying to photograph humming birds in Palm Springs last December. I staked out the tree where a particularly beautiful male usually perched and came to eat. I had known beforehand that each hummer is territorial by nature, and this one would return no matter what was there. Also, hummingbirds are quite pugnacious, and my presence would not necessarily scare him off. There were two feeders hanging in the tree. When I focused on one, he would go to the other. A stroke of genius came to me (on the second day), and I removed

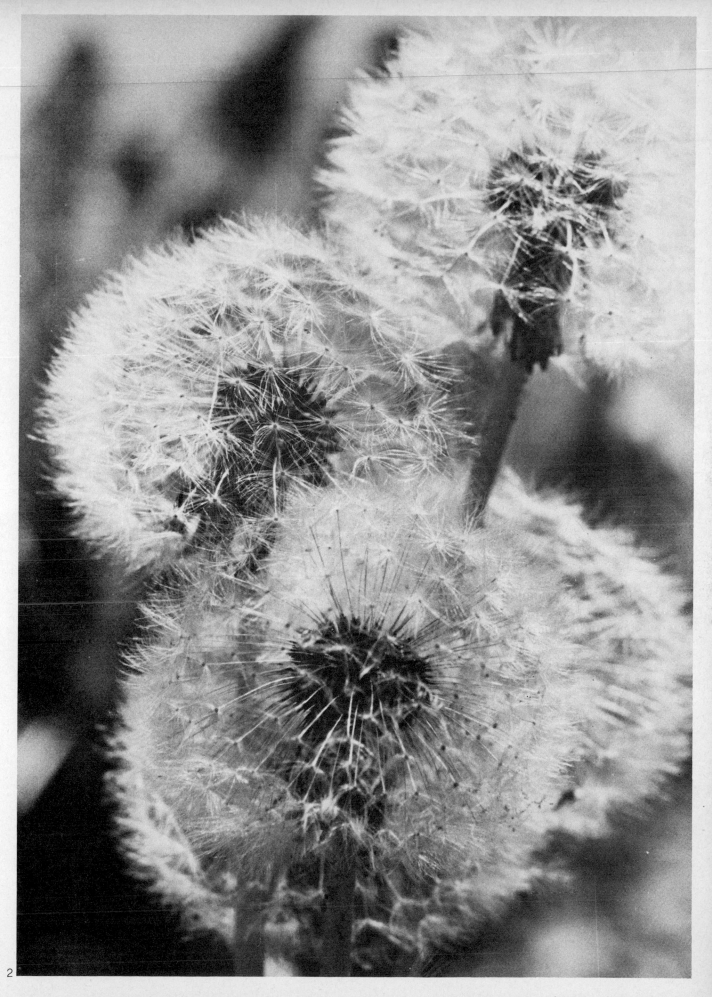

2

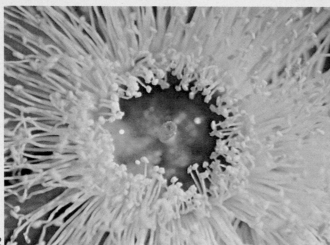

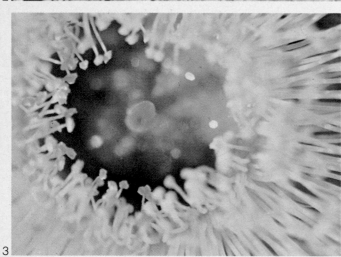

1, 2, 3. Eucalyptus blossom was cut from tree and placed where breeze would not cause movement during exposure. Series was shot with 50mm macro lens; largest image is 2X magnification using extension tubes as well. Sunlight provided the illumination.
4. Backlighting enhances interesting shape of leaf. A 200mm lens was used along with 50mm of extension tubes.
5. Soft early morning light almost causes colors of new bamboo shoots to glow. Shot was made with 200mm lens and 50mm of extension tubes.
6. Colorful live butterfly was recorded with 50mm lens and 75mm of extension. Such subjects require lots of patience.
7. Lady bug was captured on film using 100mm lens with 100mm of extension tubes. Photographing smaller life forms, such as insects and small flowers, can be physically demanding. Keep your eyes open and use plenty of film.

slide copiers

Slide copying is a logical offshoot of close-up photography. The major difference between it and what we have discussed up to now is that instead of photographing a solid object we will now be photographing a transparent object—a positive slide, ordinarily. We can also use this technique to photograph negatives to produce positive slides—color slides from color negatives, and black-and-white slides from black-and-white or color negatives.

The basic type of slide copying is to produce straight duplicates of existing slides. Let's say you have a dramatic slide of waves crashing on the rocks with the Golden Gate Bridge in the background. The exposure was right on, the sky and water were rendered exquisitely by use of a polarizing filter. Now, you want to send a copy of this slide to Aunt Minnie in Sioux City, or to a photographer friend so that he can eat his heart out in envy. You can make duplicates with a slide copier, or you can take the slide down to your photofinisher and let him send it to Kodak or some other good lab, where it will be duplicated quickly and at a modest cost. If a straight duplicate is all you want, the latter may be your best bet.

But if you want to enlarge a portion of the slide, or do some cropping, or make slight modifications in exposure or correct for color, dodge or burn-in a portion or two, devise

1

2

special color effects, or even change the basic concept of the slide through posterization or solarization effects, then the slide copier is for you. If you can conceive of an effect, you can generally produce that effect—if you understand the techniques and materials involved.

EQUIPMENT

Slide copying requires some special equipment, essentially a slide copier—a device to hold the slide being copied in the desired position. You could hand-hold the slide between the camera and the light source at the correct distance, but this obviously leaves something to be desired.

As a slide happens to be the the same size as the frame being exposed, it is evident that our basic reproduction ratio for straight duplication is 1:1, or life-size. (In actual practice, the reproduction ratio required involves a little extra magnification to account for the cropping effect of the slide mount. The slide being copied can be removed from its cardboard mount, copied at 1:1, and later remounted if a true full-frame copy is desired.)

The most simple devices for producing this 1:1 reproduction ratio do not utilize the camera lens, but rather consist of a tube containing a simple, but effective lens. One end attaches to the camera, and the other end has a holder for the slide, providing a fixed 1:1 reproduction ratio. The Dupliscope, distributed by Spiratone, is one example

1. Original slide (reproduced here from color) was shot with 200mm lens.
2. Slide copier was used to obtain larger, cropped image.
3. Miranda Optical Slide Duplicator is example of simplest type of slide copier. It attaches to camera in place of camera lens. produces 1:1 duplicates.
4. Konica Slide Copier II attaches to bellows. makes use of camera lens. This type of copier allows magnification greater than 1:1 and cropping of slide.

of this type of slide copier. With its lens, an effective aperture of f/16 is provided. Spiratone also distributes a variable reproduction ratio unit, much like a zoom, as does Prinz. The Prinz device offers a variety of ratios from 1:1 to 2.5:1. As you might imagine, the only exposure variable you have with these units is your shutter speed adjustment.

Being limited to a shutter speed adjustment is not a real limitation in slide copying. It is perfectly proper and frequently necessary to use shutter speeds of ¼ second, or even a full second, but this is no problem, because the slide copier containing the slide is attached to the camera, and will move with the camera if the camera is not held perfectly steady.

Another even more simple slide copier merely holds the slide in position in front of the lens. The camera lens is attached to extension tubes mounted on the camera. The holder then screws into the accessory receptacle of the lens and holds the slide the proper distance from the lens for a 1:1 duplicate.

For more elaborate, critical and precise work, a slide copier that attaches to the bellows is required. Most camera manufacturers offer such a combination. This combination will offer the best all-around capability. The bellows, of course, can be used alone for regular ultraclose-up work. The slide copier is a relatively inexpensive addition.

It is important that the slide copier be designed to adapt to the bellows being used. If you have a bellows of one manufacturer, it is not usually possible to use a slide copier from another manufacturer with it. The two components must be designed to work together—different bellows and slide copiers within a

given manufacturer's line may not be compatible.

SETTING UP THE SYSTEM

To set up the bellows-slide copier for use, the camera is attached to the bellows and the lens is mounted to the front of the bellows. The slide copier is then attached to the bellows rail system. On the slide copier is a small bellows that connects over the front edge of the lens and locks into place. The bellows on the slide copier is used strictly to exclude unwanted ambient light and has absolutely no effect on image size. It permits movement of the slide for focusing purposes. The extension needed to provide the desired image size on the film being exposed is set on the camera bellows, not the slide copier bellows.

The basic steps: Set the lens focusing ring on infinity. Lock the lens standard of the camera bellows unit in place near the front of the bellows rail. Put the slide to be copied in the slide copier. Move the camera standard of the camera bellows forward or back along the bellows rail to achieve the desired image size in the viewfinder, then lock it in place. Move the slide copier forward or backward until the slide is in sharp focus, and lock it in place. You are now ready to make an exposure.

It is important to lock the front (lens) standard in place near the front of the bellows rail, and to adjust image size by moving only the back (camera) standard, otherwise you might not be able to get the slide in focus.

In order to achieve a 1:1 reproduction ratio to produce a duplicate slide, you will need an amount of extension of the bellows equal to the focal length of the lens you are using. You can measure the amount of extension precisely on the bellows rail: if the front (lens) standard is set at 180mm, for example,

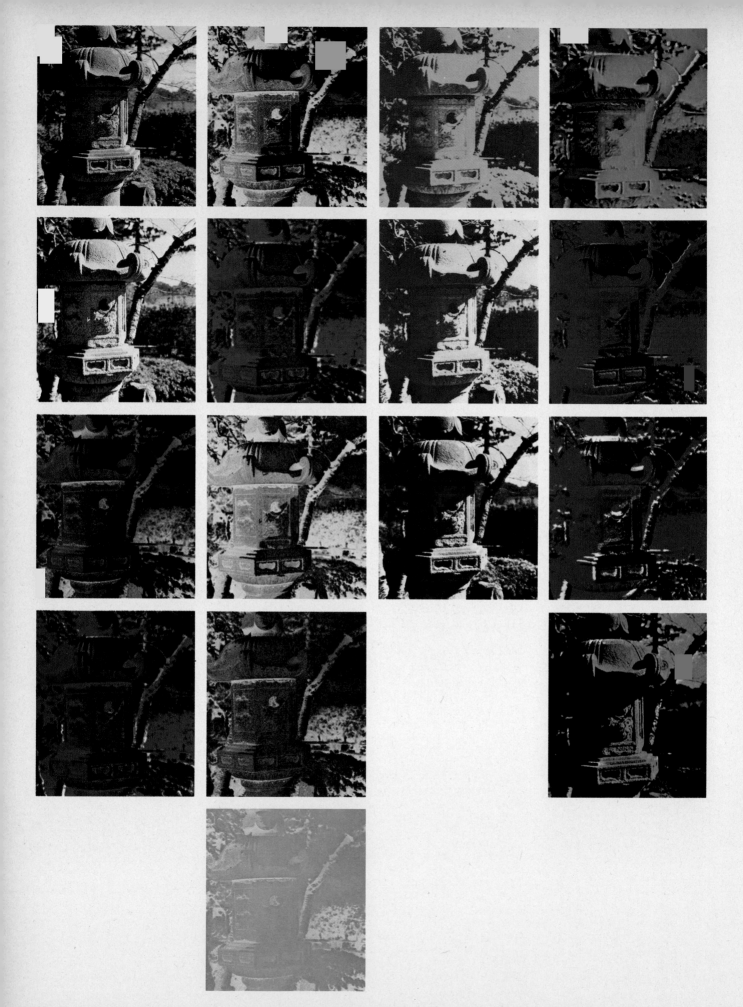

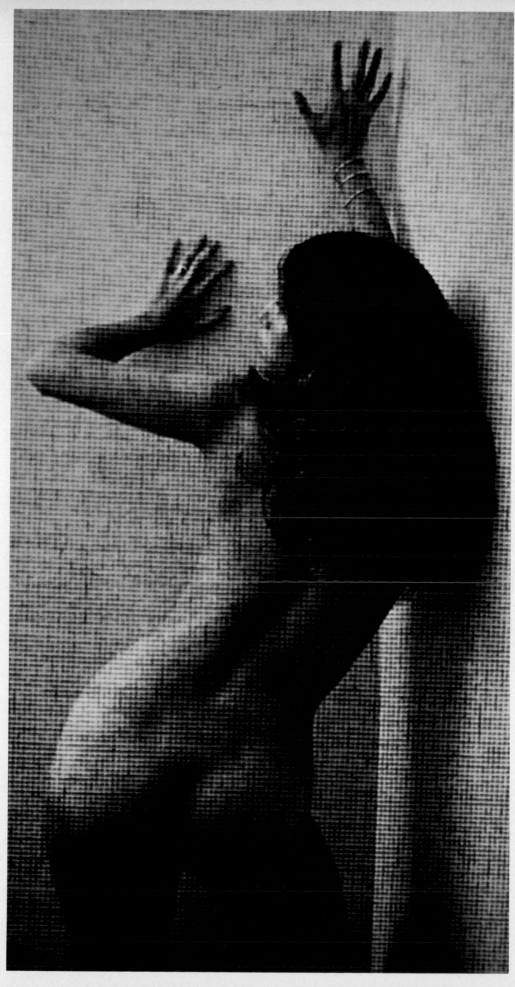

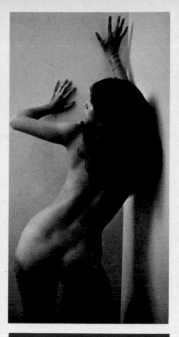

Slide copier was used to
make straight duplicate of
original of nude. Texture
screen was sandwiched with
original in slide copier
to produce effect at left.
Opposite page: Original was
duplicated straight.
Negative slides were made by
copying original on Fuji-
chrome film at various set-
tings through different
colored filters, then proc-
essing film in Kodak C-22
negative developer. The
positives were produced by
copying original on Kodak
Infrared film, again through
different filters. This
film was processed in regular
Kodak E-4 color chemicals.

and you need 50mm of extension, just subtract 50mm from 180mm to obtain the proper position for the rear (camera) standard of 130mm. However, since a 50mm lens may actually be a 49 or 52mm lens, due to manufacturing tolerances, such precise measurement of the bellows extension is not necessary for most slide copying work. For most uses, it will suffice simply to eyeball the subject through the viewfinder, increasing extension to obtain a larger image, decreasing extension by moving the rear camera standard closer to the front lens standard to obtain a smaller image. When you see what you want, lock off the camera standard, focus (by moving the slide copier) and you're all set.

NOTES ON LENSES

Since slide copying involves photographing a flat subject, flat-field lenses are the best type to use. With a normal camera lens, curvature of field will produce blurred edges on the duplicate slides.

Reversing the normal lens will produce sharper results than using it in its normal position, although the results won't be as good as those produced by a flat-field lens. As you might recall from the chapter on the bellows, reversing the camera lens provides more magnification. Normally, with the bellows in

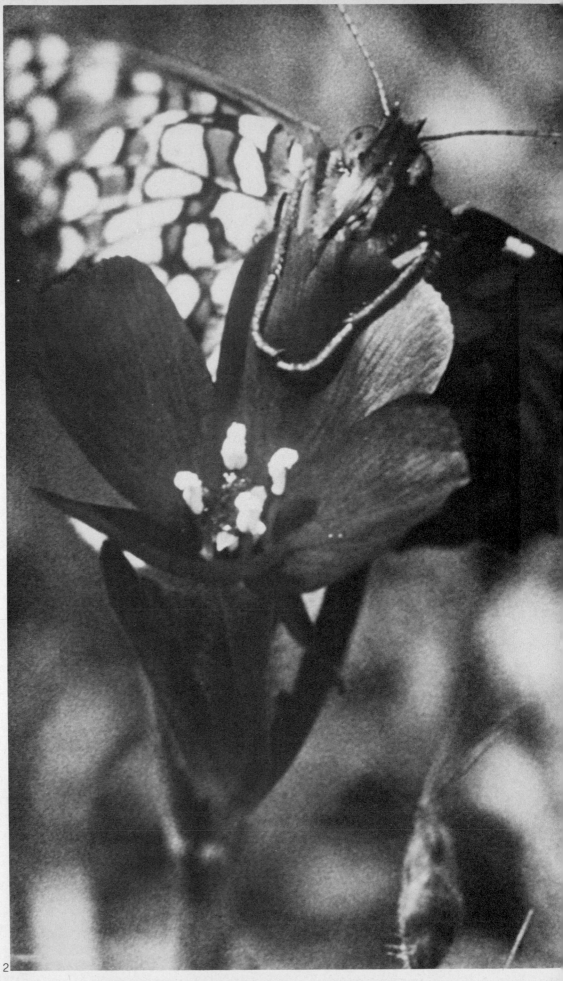

the closed (camera and lens standards closest together) position, the reproduction ratio obtained with a reversed lens will be more than 1:1, producing a magnified image. In the simple duplication of a slide, full-frame, this will not be very helpful.

It is also worth considering that when the lens is reversed on the lens standard, frequently there will be no satisfactory quick way to attach the slide copier bellows, not with the bayonet, breech-lock or screw mount facing outward. Nikon makes a ring that snaps onto the bayonet mount and provides an accessory receptacle the same as if the lens were facing forward (complete with screw threads to take filters). With the Olympus OM-1 bellows, the entire front lens standard reverses, turning the front of the lens toward the camera, with a protrusion on the back of the standard that will accept with ease the locking collar of the slide copier bellows.

When using a flat-field lens, a similar attachment problem arises. The solution, while very effective, may offend the aesthetic sensibilities of the photographer: bearing in mind that the primary purpose of the slide copier bellows is to block off ambient light, create a makeshift bellows out of black, opaque cloth and tape, or thick cardboard.

Assuming the use of 35mm format, a 35mm slide is the largest the system will accommodate. If you want to copy larger materials (2¼x2¼ transparencies, 4x5 litho films, etc.), though, there is a way. The Bowens Illumitron (distributed by Bogen) and the Honeywell Repronar allow such operations. In fact, the February 1974 issue of Petersen's *PhotoGraphic Magazine* contains plans for

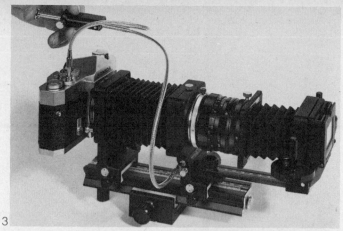

3

building a slide copier capable of such work.

LIGHTING

Once the slide copying system is set up, there arises the problem of light. Actually, any kind of light will work with these systems—sunlight, moonlight, floodlight, flash, matches, street lights—some more satisfactorily than others.

Obviously, for straight duplication it will be necessary to use a light source of sufficient intensity and color balance to be compatible with the film in the camera. Bright, reflected sunlight during the middle of the day will work quite well with daylight color films, but not the bright light obtained by pointing the slide copier system at the nice blue sky, for that would only add the color of the sky to the duplicate.

Electronic flash provides an exceptionally good light source, because its color temperature is completely compatible with daylight color films. It does not suffer from the color or intensity

4

1. Original color slide was obtained using 100mm lens and 100mm of extension.
2. Slide copier was used to increase magnification.
3. Konica slide copier shown ready for use. Bellows is attached to camera, lens is attached to bellows, and slide copier is attached to lens and by bracket to bellows.
4. Be sure to remove dust from slide before copying.

shifts that can affect daylight (orange yellow in the mornings and evenings, blue on overcast days, diminishing when a cloud blocks the light). It provides a constant color temperature and intensity that solves or eliminate many lighting problems.

Photoflood lamps work well with color film balanced for them. For specifics on what lamp to use with a given film, consult the instruction sheet for that film.

For straight, normal duplicating and copying it is important to use the correct light source. Otherwise, there will be unplanned and undesired color shifts. If it is necessary to use a light source that is not compatible with the film, corrections can be made with filters. These filters can be screwed into the lens, or sheets of the

appropriate gelatin filter can be placed between the slide being copied and the light source.

The most critical problem in lighting for slide copying is exposure determination, but this can be handled in a simple manner. One approach is to set a desired amount of extension on the bellows and put a well-exposed average slide (after all, we only keep the good exposures, assigning the remainder to the waste basket or a special storage box in the closet, right?) into the slide copier. We then make a series of test exposures.

Position the light source at a fixed distance from the diffusing glass of the slide copier, pointing directly at it. Assuming that we're using the best light source (i.e., electronic flash) and for example's sake, Ektachrome-X film (ASA 64), we for the sake of convenience place the flash unit 24 inches from the surface of the opal diffusing glass on the slide copier. If we're using an automatic flash unit, it should be set for manual operation. If the dial calculator on the flash unit does not give information for using the unit at two feet, we can refer to the guide number recommendations. Just divide the flash-to-subject distance (two feet) into the guide number (let's say it's 50 for ASA 64 film). This will give an f-stop of 25, close enough to f/22. (Rule of thumb: Divide the flash-to-subject distance in feet into the guide number, and the result is the f-stop.)

But now we have the bellows extension to consider. We can usually count on a one-stop

increase in the exposure being required for every 25mm of extension (assuming the use of a 50mm lens). So by using the 50mm of extension necessary to give a 1:1 reproduction ratio with the 50mm lens, we have to stop down from the guide-number-suggested f-stop to f/11. Allowing a one-stop increase because of the slide takes us to f/8. The diffusing glass of the slide copier will cause about a two-stop light loss, so we are now at about f/4 or f/3.5. This is where we begin our test exposures.

Our first exposure will be at f/4, and we will note this down for future reference. A good sequence then is to open up the aperture by ½-stop increments, up to about two f-stops more exposure, on succeeding exposures. Then, bracket the exposure two f-stops the other way (close the lens down) in ½-stop increments.

Should you desire to use the flash at 12 inches, simply base the trial exposures on the one-foot distance. There is little reason not to use the flash closer to the slide copier to get more light, as long as the light coverage is adequate. Your tests will give you that information.

You might want to do this same type of test with a number of slides of different types and densities. This will give you information necessary to quickly determine the exposure for almost any copying situation.

When you get the finished slides back, you can arrange them in order, refer to the notes you have taken, and see for yourself which slide represents the best exposure. This particular exposure will become your regular exposure when copying slides with 50mm of extension.

For light sources other than electronic flash, it is possible to use the camera's

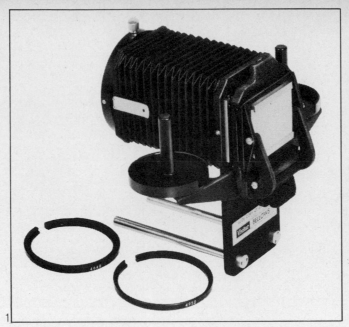

internal meter. It should give you the correct exposure.

USING THE SYSTEM

Once the hardware and lighting system have been set up, we are ready to make a series of tests. These tests will show us a great deal about the operation of the system and also give us our first good results. Some of the exposures on the test roll will likely be slides that we will keep and find useful.

I keep most of the slides that accumulate from tests, most especially the lighter, overexposed ones. These can be kept with an eye to combining with other light slides later for experimental work. Sandwiching a number of slides can produce another completely different slide with a dreamlike, surreal image.

1. Vivitar Slide Copy Attachment fits on Vivitar bellows. which can be used with several cameras.
2. Image size is determined by position of camera bellows; slide is focused by moving slide copier bellows. as shown using Vivitar units.

Many slide copier attachments for bellows can be moved in at least one direction. This is an aid in cropping, or centering the portion of the image we wish to copy. Since the camera lens is fixed in relationship to the bellows and slide copier, some movement of the slide holder is desirable.

Although we are constantly bombarded with the concept, "fill the frame," this is not always possible at the time of exposure. How many times have you had to make an exposure using a lens half the focal length needed to fill the frame? We frequently have to give precedence to the overall concept, "be sure to get the picture first."

CROPPING—The purpose of cropping a picture is to eliminate undesired portions of the image. In making an enlargement in the darkroom, this is achieved by raising the lamphouse to obtain a larger image. In slide copying, we also increase the size of the image with greater magnification, through greater extension of the

bellows. This way we can make an exposure taking in just that part of the original frame we want. It is desirable to center that portion of the original, using the adjustments on the slide copier, so as to be working with the sharpest (center) portion of the lens.

EXPOSURE CORRECTION— If an original slide is not too badly over- or underexposed, we can make a new slide that has a better density. Density, in this case, is the ability to pass or hold back light. If we consistently show (project) slides with a wide variation of exposures, the total effect is disturbing to the eye. This means our best-exposed slides frequently lose impact because the eye is trying to adjust to a new light level.

Best results are obtained from slides that are no more than a stop off in exposure. It is possible to correct slides more than a stop off in exposure, but color shifts may result, as well as changes in contrast. Color shifts may be corrected within reason, but they will not be the same as in our original concept.

When correcting poorly exposed slides in the slide copier, the adjustment is made by varying the f-stop being used on the lens. For example, if the basic f-stop we have determined from tests is f/5.6 for an average well-exposed slide, and the poorly exposed slide is dark (underexposed by one f-stop), we then make the new exposure with the slide copier system at f/4. Twice as much light will then pass through the system.

An overexposed (light) original can be corrected, conversely, by reducing the amount of light passing

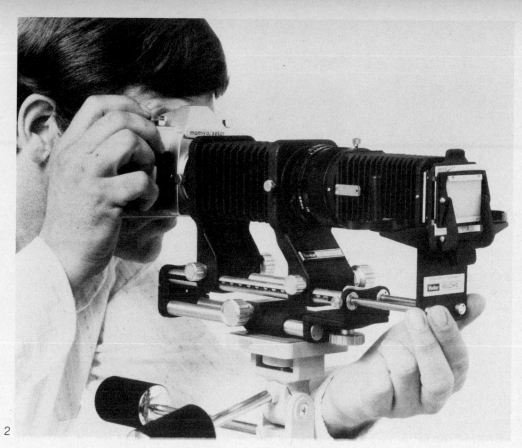

2

through the system. In this case, we would use f/8 rather than the normal f/5.6. In either case, the results will not be as good as if we had exposed the original correctly in the first place, but we should be able to salvage many otherwise not-too-good originals.

A flat original will invariably be improved in contrast, as slide copying is usually accompanied by an increase in contrast. A contrasty original presents more of a problem for the same reason: slide copying increases contrast.

Contrast can be reduced by prefogging the desired frame in the camera before making an exposure on that frame with the contrasty slide. Use of the double-exposure function of your camera will be necessary in this case.

The simplest method of prefogging, or we can call it

preexposure if that is more comfortable, is to use a neutral density filter in the slide holder in place of the original. Make the preexposure first, before the original is exposed in the slide copier system. Good results have been obtained preexposing through a Kodak Wratten 2.00 neutral density filter (available in 2x2-inch gelatin squares). This will allow roughly 1/100 of the light to pass through the system.

After the preexposure, remove the neutral density filter from the slide holder and place the contrasty original in position. Using the double-exposure function of your camera, make sure that the preexposed frame is still properly positioned in the camera. Then make the final exposure.

Do not use the neutral density filter and the original in the slide holder at the same time in the mistaken attempt to short-cut the procedure. You will only obtain an exposure of less than 1/100 of the needed exposure.

It is possible to control the degree of contrast modification by using other neutral density filters; this

information can best be obtained by trial-and-error.

This contrast modification is usually necessary even when working with an original of good exposure and contrast when using most color positive films and standard processing. The slower the color film, the more the build-up in contrast. Kodachrome, for example, a beautiful film with excellent color and fine grain, presents problems as a copy film that can best be reduced by means of preexposure through the use of neutral density filters.

One important note should be added. The exposure

through the neutral density filter should be exactly the same as the one through the original. If you are using electronic flash, the shutter speed setting is relatively meaningless; the f-stop that would be used for exposing the original should be used for preexposing.

Should you belong to the growing number of photographers who do their own processing, or even have access to a processing laboratory that will process according to an ASA modification, then there is a technique that allows you to by-pass preexposure in most instances.

(A word of caution regarding use of Kodachrome: Expose all Kodachrome films precisely according to the manufacturer's recommendations. It is all but impossible to obtain processing for Kodachromes at any speed other than the assigned ASA.)

Any film for which there are available chemicals, or kits of chemicals, can be exposed at different exposure indices and processed at home. Most manufacturers make available chemistry for processing their films. Kodak makes available chemistry for processing Ektachromes, but does *not* make available chemistry for processing Kodachromes. If you use a variety of color positive films, the Unichrome chemistry kit is helpful. The results I have achieved have been acceptable with a variety of color positive films.

Kodak has two Ektachrome processes available. They are the E-3 process and the E-4 Process. The E-3 process takes less time, but requires a reexposure step. If you can hold a reel of film in front of a floodlight for a total of about a minute, you have achieved reexposure. In the E-4 process this reexposure, which accounts

for the reversal of the image, is performed chemically, and this extends the processing time a few minutes.

The Unichrome process approximates the Kodak E-3 process, and works for many other positive color films as well. I prefer the Kodak E-4 process with Fujichrome, but have often processed it in E-3 with completely satisfactory results. Each manufacturer of films and chemistry provides precise and usable instructions. Use the one you find most convenient.

Now, the reason for this brief discussion of processing kits and chemistries: A remarkably satisfactory manner of reducing contrast and obtaining rich results in copying without resorting to preexposure is possible through these chemistries. Expose the film used in the camera for copying at half (50 percent) of its rated ASA speed. Instead of using Fujichrome at ASA 100, for example, expose it at 50. Use Ektachrome-X at 32 instead of its rated ASA 64. When the roll is finished, process in the appropriate chemistry with one change in the processing. Instead of leaving the film in the first developer for the recommended time, process for only 70 percent of the recommended time. If the recommended time in the first developer for a roll of film exposed at the usual ASA speed is eight minutes, the roll of film exposed at half its usual ASA speed (giving twice the normal exposure) is processed for six minutes. The rest of the process is followed as per the instructions; only the first developer step needs to be modified. As you might imagine, the first developer step in these chemistries can also be modified to allow exposures at increased speed ratings.

Increasing initial exposure by reducing the ASA ratings decreases the overall contrast because it is accompanied by reducing first developer time. An

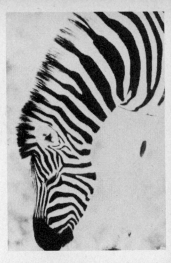

Slide copier can be used to make negative images. These can be photographed with colored filters in copier for different special effects.

increase in contrast can be obtained by decreasing initial exposures by increasing the ASA rating, accompanied by increasing the time in the first developer. Unichrome gives complete information for increasing the ASA ratings, but not for decreasing them. Kodak provides information for both operations.

Needless to say, the entire roll exposed for special processing must be exposed at the same speed. Should the speed rating be changed from frame to frame, the results will be a collection of underexposed, properly exposed and overexposed frames on the same roll.

COLOR CORRECTION—Sometimes because of situations over which we have little control it is necessary to make an original exposure where the color is wrong. The needed filter might have been left at home, the very filter that

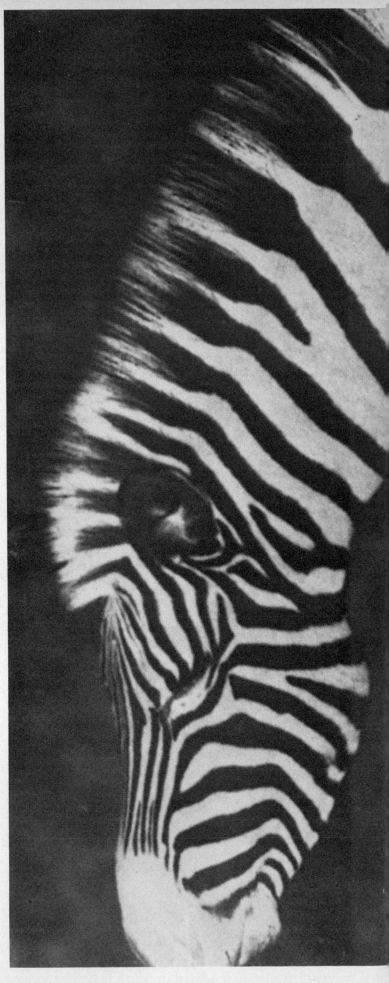

would have solved the problem in the first place. A slight problem of color correction can be corrected with the slide copier. The results will not be as good as if the color correction had been used in the original exposure, but are often better than no correction.

To determine the necessary color correction, the easiest method is to hold the slide up to a light source and then place color correction filters behind the slide. Once the color correction seems adequate, insert both the slide and the color correction filter in the slide copier. Or, an alternate method is to hold the filter between the light source and the diffusion glass of the slide copier.

Color printing filters are less expensive than color correction filters and may be substituted if you can obtain the array of colors needed. These filters will also prove useful when you get into doing experimental and special effects work.

Regular camera color filters can be used, but rarely will the full range of useful colors be available. The accessory orange camera filter is an intense orange. Most color corrections can be done with filters with a bare tinge of the correct color. All transparent color materials are useful to some degree, although not necessarily for use in color correction.

SPECIAL COLOR EFFECTS—Since color filters can be used for corrections, it stands to reason that they can also be used to create special effects. This is especially convenient in slide copier work, since changes can be made in the overall color of a copy while leaving the original unaltered. All of this new work can be done at home without fear of the changing light or weather conditions present at the

scene at the time of the original exposure.

The first general principle to keep in mind is that a filter adds its color to a copy of an original positive. This is the same rule applicable to exposing the original. Blue adds blue. Red adds red. How much of a color is added depends on the density of the filter used.

Each filter has a filter factor, which tells us how much to increase the exposure when using that filter. This factor is provided with all camera filters, but some of the individual color filters available in gelatin form may not have the factor provided, so the photographer will have to determine the exposure increases made necessary by the filter through experimentation. Kodak does publish charts of relative filter densities, and these may provide an educated guess in determining proper exposures. But when a color is added it can change the total impact of the picture. Hence, what might be a proper exposure in one respect might not produce the desired effect. The final results are subjective. What looks good is what should be used.

Most evaluations for proper exposure are based on the presence of all the colors. When one color dominates there may be difficulty in deciding just

exactly what is a "correct" exposure. Trust your own judgment. If you like an effect, it is right. After all, it is your picture. While it is helpful and instructive to copy the work of another photographer, such an approach should be just that—helpful and instructive. To slavishly imitate an existing work is limiting and ultimately unsatisfactory.

Sunsets are completely subjective. What strikes you as the most exciting aspect of a sunset may not be what excited some other person. Sometimes when I have photographed a sunset, I find that the results are not exactly what I expected. Perhaps the color isn't just right, or the contrast is lacking. By now it should be evident that both of these shortcomings can be modified to produce a more satisfactory work—perhaps one exactly matching our original impression of the scene. Possibly we will obtain a result even more striking and exciting than that anticipated.

SPECIAL EFFECTS IN GENERAL—Filters can be used to change the color of an original in the copy—by now no longer a mere duplicate—to good effect. So long as the light passes through the color, thereby adding the color to the scene, the principle can be used in other applications. As long as the material is sufficiently transparent to allow passage of light there seems to be little limit as to what materials can be used.

Texture screens are one ready example. There are a couple of sets of texture screens generally available in many camera stores, produced and packaged by Paterson. One set includes drawn cotton, dot screen, gravel and tapestry. Sandwich one of these with the original in the slide copier and the texture will be added to your copy.

You can make your own texture screens. Any regular, consistent pattern may be involved. With some high-contrast film in your camera, make normal photographs of the material, taking care to underexpose

by two or three stops. Process the film with a high-contrast developer. Some possibilities include cement walls with texture patterns, rough wood, brick walls and many of the readily available fabrics. Lighting should come from the side, and not from behind the camera.

More innovative texture patterns can include flowers or leaves. If sufficiently underexposed, in either black-and-white negatives or positive slides, they may be combined with a properly exposed scene to secure some highly interesting results. Whatever results are obtained, it is important to remember that it is the total, final effect that counts. Every step along the way simply contributes to the final effect. Whatever step can be used may be used. The limit is the imagination of the photographer. Whatever material is used (preferably another piece of film) gives best results when held in contact with the original. The commercial texture screens are safe so long as they are kept clean. Nothing should be used that will harm the original.

Should some preparation such as Vaseline be used, it may be helpful to place the original in a glass-covered mount and then apply the goop to the glass. When done, take a cotton-tipped swab and clean the copier. Make sure nothing is left that will come off on another slide later.

COMBINATIONS—Adding a texture screen to a slide is simply a combination. If you can combine a texture screen with a slide, you can certainly combine another slide with the original. This can be quite satisfactory and open up unlimited possibilities.

Selection of the original to be manipulated is important. It should have good design and be somewhat contrasty. This slide is then placed in the slide copier.

Different films can be used

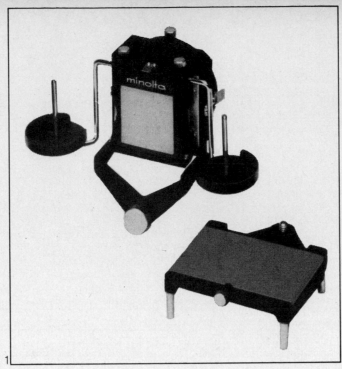

to make copies. One approach is to make a series of exposures on a regular slide film such as Ektachrome. Modify the color by using different filters, which can easily be held in the light path. A few normal exposures are desirable, even through the filters. Most useful later on will be underexposures, slides two or three stops under.

Without changing the slide or its magnification, try a roll of Ektachrome Infrared film, again changing colors by use of the filters. Somewhere along the line you may want to add a texture in one of the series being exposed in this experimental process.

These first rolls are then processed in the usual manner. With the same setup used for the first rolls, expose another roll of regular slide material with the various color filters. Then arrange to have this roll processed as a negative. If you do it yourself, process it in the Kodak C-22 process, which is used for developing Kodacolor (or use a comparable kit designed for developing negative films). This will produce a roll of negative images of pretty intense color, without the orange color of traditional color negatives.

This will provide you with enough images for a first attempt. All the images are

the same size, since they were all made with the same original and the same magnification. While it is helpful to have the slides in mounts for handling ease, it is not necessary. It is nearly as easy to just cut the frames apart and keep them in three separate piles. Cotton gloves, available in many camera stores, will prevent fingerprints, unless, of course, you are preparing a commemorative series for the FBI.

Hold one slide over another against a light source, and try different combinations until you find one that suits your fancy. Try combining a positive and a negative, which can produce some remarkable colors. Perhaps a slide made on infrared will enhance the combination. You can try for precise registration, that is, with all of the lines or images in perfect alignment. Possibly more interesting results can be obtained by moving one slide slightly out of alignment. You will know

when you have an unusual, exciting combination, because you'll be able to see it.

You can then place all the selected slides in one mount and place them in the slide copier. Another photograph is then made of the combination.

Once you have successfully completed one combination, there are many others to be considered. The momentum you gain by one success can very easily carry you to other successes.

So far we have worked in combinations of colors. There is no reason why black-and-white can't be worked in for interesting combinations. It is a matter of films and chemistries. You can use extremely grainy films or contrasty films. Positive black-and-white films and litho films are special-effects films that can be combined with regular black-and-white films. And the ultimate combinations involve black-and-white films and color films.

If you want to get really tricky, you can use the high-contrast or litho film to make masks. This means you can eliminate some areas or add others. This technique can be used to add silhouettes to otherwise bland scenes. Make a drawing in relative scale and then photograph it with litho film. Litho film is best processed in an A and B solution that can be found in a few stores catering to graphic arts customers. If the litho mask is to be combined with a positive, it will first be desirable to make a copy of the litho original. This copy can then be sandwiched with the color positive original.

If this technique is to be used in making titles, the first litho slide will be sufficient. First lay out the material and the words in the title on white cardboard. All sorts of letters are available from art stores. With the litho film, make a copy of the title material. Properly exposed, this will produce clear letters on a black, opaque slide. When such a slide is placed in the copier, give it plenty of

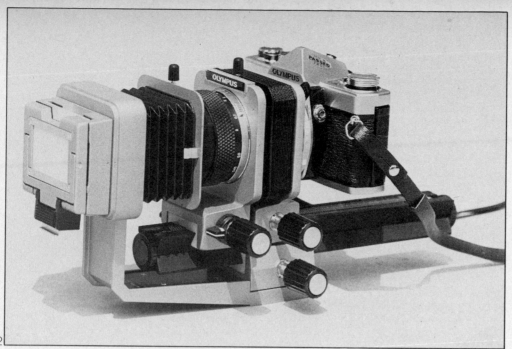

grain, with a compensating developer such as TEC. It is the compensating action that reduces the contrast to an acceptable limit. From these negatives excellent prints may be obtained.

Interesting color combinations can be derived from regular black-and-white negatives and litho positives and litho negatives. When these are held in the slide copier and there is positive color film in the camera, it is easy to add color from filters. These can be manipulated in the same manner as any other materials. One cannot expect to obtain a realistic color scene in this manner; the colors added will be arbitrary and not at all related to reality.

SUMMARY

Slide copying is a logical extension of close-up photography. It offers a means to making pictures of a nature that can excite and stimulate the novice as well as the veteran photographer. The tools are simple and relatively inexpensive.

There seems to be little limit to what materials, films and chemistry can be used. If a final result can be visualized, then it can usually be produced. And reproduced, time and time again.

It is here that the imagination can be turned completely loose. As in art, the more exciting results can then be converted to large prints by a professional laboratory. What strikes you as an exciting photograph may very well appeal to others. I have seen a number of prints of this nature, made by the slide copier, on sale at sidewalk art shows. Boutiques and head shops could even provide a sales outlet, providing the material is good.

There is only one way to find out if you like the work you can do with the slide copier and if you can sell that work. Try it. □

exposure—two or three times that for a normal exposure. This will heavily overexpose the area on the film in the camera where the light strikes. As you remember, where the overexposure occurs, the slide will be white. This will be the letters on the positive exposed through the litho slide. The original slide to be used with the lettering can then be exposed in a normal, regular way. This will produce a slide with white lettering.

For black lettering on a regular slide, carry the litho mask one step further, making a positive of the litho negative. When this is sandwiched with the original slide, only the one exposure is necessary, for the areas where light is held back will not be exposed and will reproduce black on the camera film.

Of course, you can sandwich two existing slides, two originals of different subjects, to produce new creations, using these techniques.

When it is realized what can be done with the slide copier, one of the first

1. Minolta Slide/Strip Film Copier, like some others, allows copying mounted slides or uncut film strips.
2. To produce 1:1 reproduction ratio, camera bellows extension must equal focal length of lens. With most bellows, 50mm of extension is produced when camera and lens standards are closest to each other; this is setting to use for 1:1 ratio with 50mm lens on bellows.

reactions is, "Wow! Now I can get out all those slides I like best and make exposures on negative film and get prints made!"

Within the limitations of the materials this is true. Consider that the professional custom labs have to make internegatives before they can produce quality custom prints. These internegatives are just that, steps between the slide and the print. They are different from negatives.

Internegative material is relatively expensive and has to be processed in special internegative chemistry. Regular negative material alone will not produce quality results. Good and fair results can be obtained if Kodacolor material is processed in modified Unicolor negative processing chemistry. Otherwise, if you are content with less than optimum results, securing prints in this manner may

prove acceptable.

One eminently useful application of the slide copying process is to obtain black-and-white negatives from slides, to be used for making black-and-white prints. One problem that is the same as in making straight color positive duplicates of slides is that of excess contrast.

One useful approach is to use Tri-X film, which is then processed in a soft developer such as Microdol. This combines a low-contrast film with a low-contrast developer. Another combination I have found useful is Ilford HP4 processed in Rodinal. Other authorities use Panatomic-X, known to be a high-contrast film with extremely fine

close-up optics

For a moment let's think about the 50mm normal lens. It was designed for normal distance work, that is, where the distance from the lens to the subject is greater than the distance from the lens to the film plane. It will allow focus from infinity down to about three feet. Most lenses are designed to perform best at one focused distance, and for most normal lenses this distance is infinity. Manufacturing a lens to perform best at one focused distance—at that distance the lens is corrected to minimize most of the significant lens aberrations—allows the manufacturer to a modest cost. Most aberrations will remain, since they cannot be completely eliminated, but they will not interfere with acceptable performance.

By experience we know that normal lenses work well in their designed focusing range, when the distance between the lens and subject is greater than the distance between lens and film plane. But problems in sharpness and resolution begin when this relationship is reversed—when the distance between the lens and film plane exceeds the distance between lens and subject—as when using bellows or extension tubes. It is for this very reason that

Electronic components were photographed using 200mm Medical Nikkor lens. Note magnification imprint in lower right-hand corner.

manufacturers recommended reversing the lens. At such close distances, this tends to reestablish the relationships of the original lens design. By experience I can assure you that getting 2X magnification with the lens reversed results in better definition and resolution than getting the same 2X magnification with the lens in the normal position.

Faster lenses are designed to gather light, and do that job admirably. But the extreme curved surfaces of these lenses produce blurred, unsharp edges in close-up photographs. Stopping the lens down to take advantage of the flatter, sharper center portions of the lens will reduce this curvature-caused lack of sharpness, but will not completely eliminate it. And greater magnifications call for longer exposures, so we may be forced to use wider open apertures.

FLAT-FIELD LENSES

Flat-field lenses are designed for close-up work, and a good example of a flat-field lens is the familiar enlarger lens. So well are these adapted for close-up work that frequently you will find the least expensive enlarging lens performing better than an expensive camera lens. This is particularly true in photographing flat matter such as stamps, letters and other photographs.

Normal lenses do not focus on flat planes. If a subject is 15 feet from the center axis of the lens, it will be in focus at 15 feet. If the subject moves from the center to either the left or the right, it must move in an arc to remain in focus. We can think of the camera being the center of a circle. If that circle is 15 feet from the camera, then any point on that circle will be in focus with the lens set at 15 feet.

Flat matter, as you can see, presents a problem. Flat-field lenses are designed to provide even flat focusing. In close-up work such capability is a definite plus.

Several manufacturers also market special lenses designed for use on bellows. These are called short-mount or bellows lenses. They fall into the general category of flat-field lenses. All lenses in this category require some method of focusing, since they have no focusing mounts. Because of this, these lenses can be used on a bellows to focus objects at infinity. This is out of their designed-use range, so don't expect them to perform as well at infinity as standard camera lenses. I have used a 105mm bellows lens on a bellows for portraiture and have no complaint about the results. It just happened to work out right.

The highest grade enlarging lenses, most particularly those with Leica thread mounts, can be adapted to some bellows systems. This is true in the case of the Vivitar and Soligor Multiflex bellows systems, and can add some very sharp special-purpose lenses to our close-up inventory...at a moderate cost. Some focal lengths of Omegaron, Componon and El Nikkor enlarging lenses possess Leica thread mounts. If you are not already committed to a heavy inventory of close-up equipment, this possibility may be well worth considering.

Normal lenses work fairly well to 3 or 4X magnification, using them reversed. If the manufacturer recommends reversing the lens in ultraclose-up photography, take their

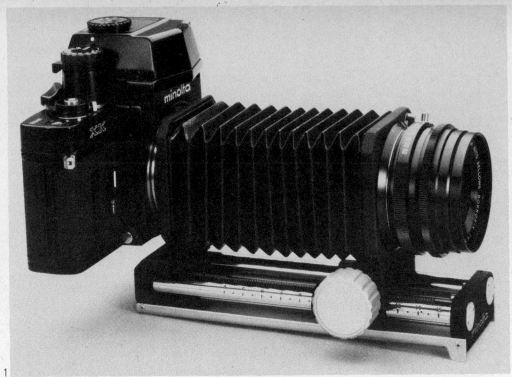

1

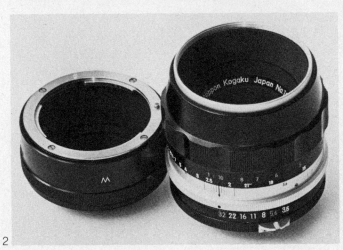

2

3

1. Minolta 100mm Auto Bellows Rokkor-X lens has focusing range from 1:1 reproduction ratio to infinity using bellows to focus.
2. Macro lenses like this 55mm Micro Nikkor allow focusing down to 1:2 reproduction ratio with no need for extension devices. Long focusing mount necessary to produce this great focusing range results in recessed front element of lens. which in turn makes lens hood unnecessary. Accessory extension ring allows 1:1 reproduction ratio.
3. Adapters such as this from Minolta permit the use of Leica-thread enlarging lenses for excellent quality copy work with bellows.

4

5

6

7

8

4. 50mm SMC Macro-Takumar lens allows continuous focusing from eight inches to infinity.
5 Flat-field bellows lens, like this Konica Auto Macro Hexanon 105mm, is excellent for close-up work, especially for copying flat matter. Such lenses have no focusing mount; focusing is done by bellows.

6. This 100mm SMCT lens for Pentax is another example of short-mount bellows lens excellent for close-ups.
7. Fast normal camera lens gathers light well. but has too much curvature of field for serious close-up work.
8. 200mm Medical Nikkor lens has built-in ring light flash unit for flat, even lighting of subjects.

word; they know how it was designed. Most recommend reversing after you pass the 1:1 reproduction ratio.

MACRO LENSES

Normal lenses (the 50mm on a 35mm SLR) focus down to about 18 inches. About a decade ago, when rangefinder cameras were in vogue, normal lenses focused down to about three feet, a practical limitation when parallax viewing problems existed. Development of the SLR eliminated parallax problems, for viewing is done through the lens.

Focusing is accomplished by moving the optical portion of the lens forward (away from the camera) by mechanical means. Keeping cost and production problems down is the reason for the closest focusing distance being set at about 18 inches. The lens has to be moved only a short distance. If a 35mm lens is moved the same distance, the closest focusing distance will be about 12 inches.

The macro lens, which will focus close enough to produce a 1:2 reproduction ratio, became technically feasible with the development of extended helical focusing in the lens barrel. Part of the additional cost of the special mechanical development was offset by producing a slower lens, but with the limited depth of field in close-up work, the need for apertures on the order of f/1.2 or f/2 is almost nonexistent. The slower macro lens also almost totally eliminates curvature of field, placing it in the same quality area as

flat-field lenses without the need of alternative focusing devices.

Most macro lens manufacturers make available a short extension tube for their macro lenses that will permit 1:1 reproduction ratios.

Macro lenses produce excellent results in close-up work, but they don't perform quite as well as normal camera lenses at greater working distances, although it would be hard to notice this in 8x10 prints.

MEDICAL NIKKOR

In a class virtually alone is the 200mm Medical Nikkor lens. Various reproduction ratios are obtained by interchanging specially designed elements. The basic design concept was to provide a lens that could be used in an operating room close enough to obtain a good-sized image, yet from far enough back to be out of the way of the surgeons.

An electronic flash ring light is built into the front of the lens. Once the reproduction ratio is set and locked in, the light output is determined automatically.

Another ring on the lens barrel allows imprinting information on the exposed frame. One can designate frame number or reproduction ratio. For the right purposes this lens is invaluable. And expensive, for both the lens and the power supply for the flash come together and are needed together. The Medical Nikkor can be used for most close-up work as well as for purely medical work. The flat lighting provided by the ring light gives maximum information; that is, very little detail will be lost in the shadows. □

Tile flower encountered at Disneyland and engraved figure in brass ash tray aro two examples of good subjects for macro lenses.

lighting

There are three basic kinds of lighting: front lighting, sidelighting and backlighting. Each has its advantages and disadvantages in close-up photography.

FRONT LIGHTING—Front lighting refers to light striking the front of the subject, not to light in front of the camera. Front lighting is flat; shadows are cast behind the subject, and little texture will show in its surface. If the subject has no texture, or you don't want to show it, front lighting is what you want to use.

One problem with front lighting in close-up work is that the lens, or even the photographer, may cast a shadow on the subject. This can be minimized by using a longer focal length lens, or, if that is not possible, by using a reflector or mirror to direct light into the shadows.

SIDELIGHTING—Sidelighting refers to light coming from the side of the subject. Such cross lighting is excellent for bringing out the texture of a subject, because each little raised point on the subject will cast a shadow to the side.

BACKLIGHTING—Backlighting refers to light coming from behind the subject. Backlighting is excellent with transparent or translucent subjects, making them really ''come alive.'' For best results, backlighting should be diffused to minimize lens flare.

DIFFUSE LIGHTING—Lighting for close-up work should generally be as even as possible, and this is best done through diffusion. Any light source can be diffused by placing a diffusion screen between it and the subject. Kodapak, a translucent material that will pass a large amount of light and at the same time give diffusion, is available in sheets at some camera shops. Tracing paper will serve the same purpose. A clean white handkerchief will diffuse electronic flash, reducing the output by about one stop in the process.

Diffuse lighting will eliminate problems caused by glare from shiny subjects such as metals and glass.

LIGHT SOURCES

DAYLIGHT—Daylight is the least expensive light source for close-up work. It is fairly bright and can be controlled to some extent by the use of reflectors. Daylight color films will produce excellent results with daylight as the light source.

Bright, direct (frontal) sunlight is pretty harsh; it should be diffused for best results. Reflectors can be used to direct daylight into side- or backlighting when necessary.

Daylight changes color throughout the day; most daylight color films are balanced for the color of daylight at around noon. Due to the position of the sun (almost straight overhead) at noon, this is not the best time to shoot close-ups using daylight. In the morning or afternoon, the farther you get from noon either direction, daylight becomes more and more orange, and a slightly bluish filter might be needed to produce more proper-appearing color in the photos, unless the slightly warm rendition of the colors is desired.

One of the main problems with daylight is that it isn't always there. At night, obviously, another light source is needed. On overcast days, the daylight is diffused, but may not be bright enough to use with slow films and a lot of extension with live (moving) subjects.

ELECTRONIC FLASH—This is the best light source for close-up work. You can aim it just where you want it, any time, in any weather. It is bright enough to allow small apertures for sufficient depth of field, and its short duration will stop moving subjects or the effects of slight camera movement. Electronic flash is about the same color as daylight, and so can be used with daylight color films. It can also be used in conjunction with daylight to produce oft-desired effects.

While we could use the built-in camera light meter for determining exposure with daylight as the light source, we have to calculate our exposures with electronic flash. (Close-up working distances are usually too close to use the automatic feature of auto flash units.)

Guide numbers used to calculate exposure with electronic flash units are based on both the light output of the unit and the amount of light reflected from nearby objects. In close-up work, we rely more on the output of the unit and less on nearby reflecting surfaces, so it's a good idea to shoot a test roll to determine guide numbers for close-up work.

One approach to determining flash exposure in close-up work is to find the guide number for our combination of flash unit and film used. We then determine which f-stop we want to use. By dividing that f-stop into the guide number, we obtain the distance the flash must be from the subject. For example, if the guide number for our unit and ASA 50 film is 50, and we want to use an f-stop of f/8, this works out:

$$\frac{GN50}{8} = 6.25$$

This means that the light should be 6¼ feet from the subject in order for us to use f/8 for exposure.

Now if we have 25mm of extension between our 50mm lens and the camera, we know that this reduces the light reaching the film by one full f-stop. This could mean that we should open the lens an f-stop to f/5.6. But we still want to use f/8. How do we solve this problem? Simple. Leave the lens set at f/8. But in the calculation we pretend that we are using f/11 as the aperture:

$$\frac{GN50}{11} = 4.5$$

We should place the light 4½ feet from the subject to compensate for the one f-stop of light lost because of the extension.

How did we decide to divide by f/11? Adding 25mm of extension decreased the light reaching the film by one stop, the

1. Sidelighting (cross-lighting) brings out the texture in subjects.
2. Sidelighting with card held to cast shadow on background produces better subject/background separation, eliminates shadows.
3. Diffuse lighting is soft and even, is produced by placing translucent material between light and subject.

equivalent of stopping down from f/8 to f/11.

Keeping the aperture at f/8, if we use 50mm of extension, we'd have a two-stop correction, the equivalent of stopping down from f/8 to f/16, so we would in this case divide the guide number by 16 to get the proper distance the light should be from the object, roughly three feet.

Another approach is to put the light close and then determine the usable f-stop. For example, we place the light one foot away from the subject. With a guide number of 50, our normal exposure with no extension would be f/50. Most likely our lens does not have this aperture setting. A stop of f/50 is close to f/45 in the regular f-stop progression. If 25mm of extension reduces the light by one stop, whis would bring us to f/32, still beyond the range of most lenses. With 50mm of extension, two stops are lost, bringing us to f/22. Some lenses have this setting, so we may now be in business. Now where can we use this much light? On the bellows, of course.

Bellows units start at about 50mm of extension. With 75mm of extension for our normal 50mm lens, the f-stop would be f/16 with this light source one foot from the subject.

We have a choice of selecting an f-stop and moving the light, or selecting a convenient distance for the light and changing the f-stop. One resourceful photographer who used the bellows a lot came up with an interesting application of moving the light and keeping the same f-stop. He simply taped the electronic flash directly over the lens, using some material to tilt the flash so that it would always be pointing at the subject in the close-up bellows work. Once he had determined his exposure at one aperture (by experimentation), each time he extended the bellows he

2

3

1. Weird, unworldly effect was produced by combination of strong sidelighting and heat-distorted plastic disk.
2. Lighting was arranged to define shapes on plastic foam packing material, shot with 50mm macro lens.
3. Sidelighting again adds shape and modeling to knot-hole in the making on living tree. Normal 50mm lens and 25mm extension tube got photographer in close.

also changed the distance between the flash and the subject.

Remember, as we increase extension, we decrease the amount of light hitting the film. But as we increase extension in this case, we also move the light closer, which increases the light reaching the subject. This is about as close as we can come to automatic flash exposures.

A long PC cord may be used to connect the flash unit to the camera's sync terminal when the flash is used off-camera. The flash unit is then held in position by hand, or better yet, by a support—books, camera bag, tripod, etc. Good strong tape, such as air conditioning duct tape

1

2

get a decent exposure. If the object flies away, that is an acceptable reason.

Bracketing exposures means making one exposure at the determined setting, then making one or two exposures at less than the determined setting, and one or two at more than the determined setting. You can work in half-stop increments and usually come up with one excellent exposure.

RING LIGHTS—The big problem in extreme close-up work is getting light between the lens and subject. It stands to reason that if we could wrap light around the lens, we could solve this problem.

Several flash and camera manufacturers make such lights. Nikon makes one to fit its lenses with 52mm accessory receptacles. Honeywell has a light to fit 49mm accessory sizes. Canon has one to fit its lenses. If your lenses have the same size accessory receptacles, then you can use these lights on your lenses. If your accessory size is smaller, then a simple step-up ring should allow you to use these lights.

These are special lights for a limited market. As a result, ring lights are somewhat expensive. But if you do a lot of work where these lights would solve your problems, they will be worth the investment. Exposure determination is worked out on charts based on magnification, and that is part of what you will be paying for when you buy a ring light flash unit.

The lighting these units provide is even and flat. Highly reflective surfaces will have little circles of light that look unnatural—highlights in the eye of a frog in reality are not circles—but that can be the least of our problems if we need the light.

COPY WORK

Straight copying (of photographs, documents,

available in most hardware stores, can hold the flash unit in place. Lacking a suitable flash unit support, try having a friend hold it.

Once you have worked out basic exposures, these exposures will generally hold true every time you work in the close-up area. You may wish to allow more light for dark subjects and less light for light subjects. One of the best ways to get a correct exposure, even with subjects of different reflective natures, is to bracket your exposures if at all possible. Once you have gone to the trouble of setting up the camera and bellows and light source, there is little reason not to

1. In black-and-white, tones and textures have to make up for lack of color, expecially in flower shots.
2. Dried blossom was found on display in florist's window. Lighting provides contrast between blossom and back-ground. Shot was made with 50mm macro lens.
3. Leaves can be depended on to provide interesting de-sign patterns, even when no color is shown. Sidelighting emphasizes design texture, aided by printing on high-contrast paper.

etc.) is one useful application of close-up techniques, and it involves some additional lighting considerations. Evenness of illumination and elimination of glare are necessities here.

If one side of an object being copied receives more light than the other, the variation in tonal value will be disturbing and the bright side may make some of the information unreadable.

Glare can totally eliminate some of the desired information. Hot spots can be done away with by moving the lights off to about a 45-degree angle, halfway between front and sidelighting. The bright reflections will then not enter the camera lens.

Evenness of illumination can be produced by using two lights, one on each side of the camera, at 45-degree angles to the copy. Best results are obtained by using four lights of less intensity, two on each side of the camera. If you are a copy buff, then think seriously about the four-light setup.

If you are using tungsten lamps, you will have to use a color film balanced for those lights. Ordinary incandescent lamps that you use in the home are not particularly good. You will have to use photofloods or flood lights. When using these light sources, use color films balanced for them, or use the appropriate filter with color films balanced for daylight. Consult the film instruction sheet for the recommended lighting and filters.

For copying with black-and-white films, just about any kind of light can be used. Color balance is not a consideration in black-and-white work, but evenness of illumination and glare elimination are still important. ☐

2

1. Flat front lighting tends to make texture disappear.
2. If subject has texture, sidelighting will emphasize it.
3. If you have only one light, a makeshift reflector can help provide fairly even lighting for copying, but two lights are far better.

3

subjects

Now that you know how to make close-up photographs, you are perhaps wondering what you should take pictures of. The most obvious answer is photograph things you are interested in. If you are a stamp or coin collector, photograph examples from your collection. If you're into sea shells, flowers, bugs, plastic models or anything else small, photograph it.

If you are a collector, you can exchange collections with other collectors through close-up photography. You can move in really close and photograph fine details of a model airplane, or the unique flaw in the date of a coin. You can copy the photographs other collectors send to you, if they want them back. You can photograph a small sea shell 1:1, and make a large blow-up to study fine details.

Perhaps you are interested in large objects that don't need the techniques of close-up photography to capture them on film. You can still use these techniques for shots of small details on your subject, things you wouldn't notice in a normal photo. If you are a model airplane buff, you might get the opportunity to photograph details on the real counterpart of the model plane you are building. How-to projects for magazines or clubs can make good use of close-up techniques.

If you're a collector, shoot close-ups of your collection. Use of bellows allowed filling frame with four half dollars used in the United States since 1900.

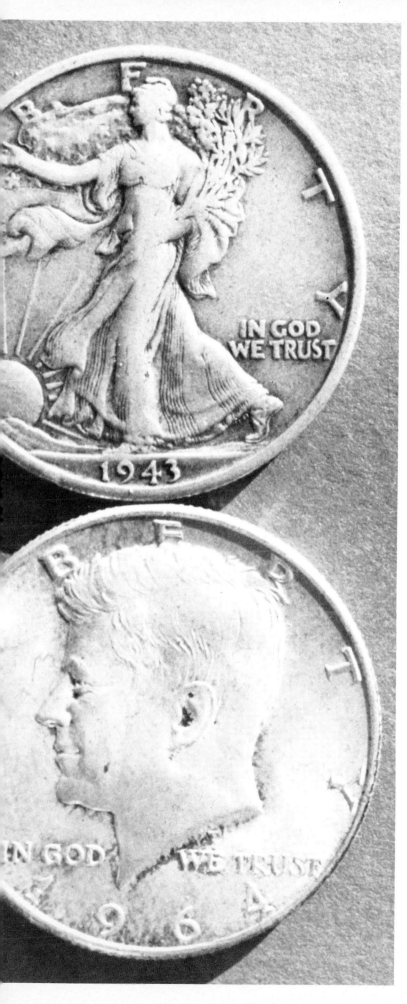

Your own interests are the obvious place to start looking for close-up subjects. What if you have no interests? That's not likely. If you've read this far, you're certainly interested in photography. Shoot close-ups of your equipment for practice. But you can always shoot pictures for others who have interests. Once you've got the techniques of close-up work down pat from practicing on your surplus camera gear, contact local model clubs, flower clubs, nature clubs, stamp or coin clubs and the like, and see if anyone there can use your services. You might make some money, and you might even gain an interest.

If the local enthusiasts are not in need of your talents at the moment, you can always duplicate your entire slide collection, or make black-and-white copy negatives of your favorites.

Microfilming is another possibility. Microfilming means making full-frame copies of larger-than-full-frame items, such as old irreplaceable newspapers or magazines. Flat-field lenses and enough close-up equipment to fill the frame with the subject are required for this work. Schools, libraries, and businesses go in for a lot of microfilming.

Then there's the creative art side of close-up subject choosing. All kinds of everyday things can be turned into abstract art through close-up photography. The idea is, as a philosopher once said, to make the new familiar and the familiar new. Knot holes, weathered paint on a wall, broken glass and other such ''found'' objects can become works of art of sorts for the close up photographer.

In short, anything small makes a good subject for close-up photography, as does a small portion of something large. The great variety of close-up subjects can provide challenge for our imagination, and our photographic skills lighting the subject to best advantage, dealing with limited depth of field and three-dimensional subjects (one solution is to focus on the nearest part of the subject), making the proper exposure, separating the subject from its background (using a red filter will lighten that red flower that green bug is squatting on in a black-and-white photo—lots of things you do in normal photography apply to close-ups as well).

Fortunately there are enough subjects to keep us content in close-up work for a long time. The primary qualification for a subject for close-up photography is that it measure less than eight inches in diameter for a 50mm lens. Still, the concept of close-up applies, in my opinion, to photography of small animals, birds, etc., where extension added to a telephoto lens helps capture a picture that would otherwise be missed.

Most of us at one time or another have shot a picture of a bird soaring in the sky. At the time of exposure our mind tells us that the bird is the size of an albatross. The image we get back from the finisher wipes out this impression, for the size of the bird's image approximates that of an ant seen from 100 yards away. If we have a good exposure, however, we can use the slide copier to enlarge that portion of the image. This too is an example of close-up photography. □

Models make good subjects for close-up work. Scale-model enthusiasts want photos like these for reference. Detail added by other model makers can be compared to histories in search for ultimate authenticity. Macro lens produced these shots.

1. Peeling paint on weathered boards can create exciting visual patterns. This one was enhanced by making high-contrast print.
2. Fossils on display at museum take on abstract pattern when photographed with a macro lens.
3. 4. Using filters can help to separate subject from background. Here, a red filter lightened red flower and darkened green background to provide separation.

3

4

1. Animals make good subjects, but require a lot of patience and electronic flash for indoor photography.
2. Graffiti is suitable target for normal lens with bellows unit, depending on the effect desired.

1. Bust of Joseph Haydn
makes good close-up subject.
2. Double-exposure technique
superimposed some of Haydn's
music over bust of composer.
3. High-contrast copy film
can be used to photograph
drawings for unusual
interesting effects.
4. Coming in close to candle
holder with macro lens pro-
duced unusual composition.

4

technical appendix

This section contains information that, while not essential to being able to do close-up photography, will help round out your close-up photography education.

DEPTH OF FIELD

Depth of field is the zone of apparent sharpness existing in front of and behind the point focused upon. The extent of this zone depends on several things, among them the aperture used and the distance between the lens and the subject. The smaller the aperture (the larger the f-number), the greater the depth of field. The greater the distance between the lens and the subject, the greater the depth of field.

In close-up photography, depth of field is critically important, for even with the smallest apertures the zone is extremely small at such lens-to-subject distances. The closer the lens comes to the subject (the greater the magnification), the smaller the zone of acceptable sharpness becomes; at extreme magnifications, depth of field is all but nonexistent.

1, 2. A lens is its stated focal length when focused at infinity. As the lens is focused on closer objects, it grows slightly longer. Since the f-number marked on the lens is the ratio between the diameter of the aperture and the focal length of the lens, the f-number becomes slightly greater when the lens is focused closer than infinity. For most purposes, this difference between the marked f-number and the effective f-number is negligible. But when extension tubes or bellows are used, greatly increasing the distance between the lens and the film plane, exposure correction must be made to compensate for this difference.

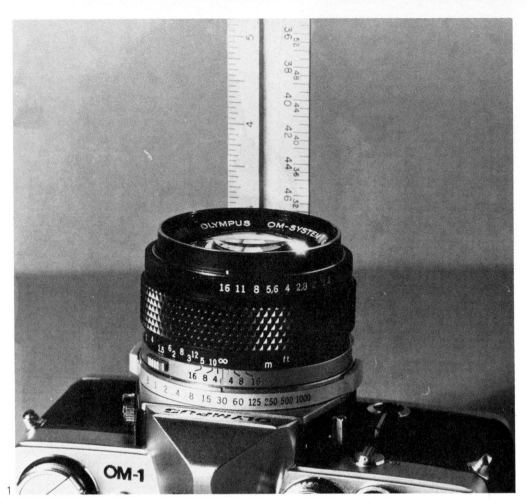

1

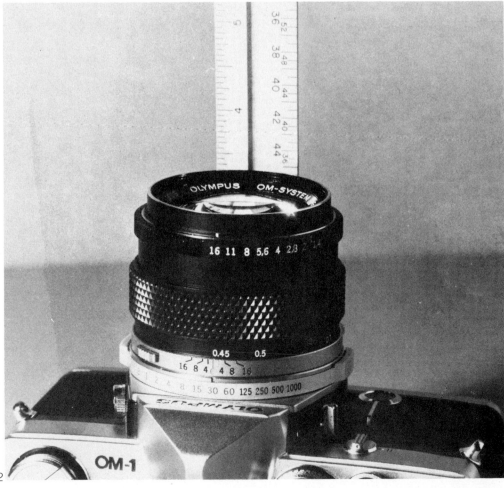

2

Critical focusing in close-up photography is therefore a must. Many photos are lost simply because of the difficulty in maintaining focus. Just breathing can move the camera out of focus.

Changing to a wide-angle lens won't help, because regardless of the focal length of the lens, the depth of field in feet and inches is identical so long as the image size is identical. If we obtain an image size of one inch with a 50mm lens set at f/8 and have a depth of field zone of 0.2 inch, and we then obtain an image size of one inch with a 24mm lens set at f/8, our depth of field zone will still be 0.2 inch. Which means that just breathing can still move the camera out of focus.

Of course, since we will be closer to the subject to produce the one-inch image size with the 24mm lens than with the 50mm, the apparent zone of sharpness will be greater. If that 0.2-inch depth of field consists of 0.1 inch in front of the subject and 0.1 inch behind the subject, and we are one inch away with the 24mm lens, then 10 percent (0.1 inch into one inch) of the area between the subject and lens will appear sharp. With the 50mm lens, which would be two inches away from the same subject to produce the same image size, only five percent (0.1 inch into two inches) of this area would appear sharp. But the problems of maintaining focus while breathing or trying to photograph a bug that is moving are the same with either lens: keeping the camera within 0.1 inch either side of the point focused on.

In short, use whatever lens will provide the most convenient working distance, stop it down as far as possible, and focus very carefully.

EXTENSION

Throughout this book we have talked in terms of extension, so by now you should know what extension is: the space that must be put between the lens and the camera in order to produce a given reproduction ratio.

Once we have determined our desired reproduction ratio, it is no real problem to figure out how much extension we need in order to fill the frame; we just multiply the focal length of the lens we're using by the desired reproduction ratio. You might recall that a reproduction ratio can be expressed in several ways: as a ratio (1:2), as a fraction ($\frac{1}{2}$) or as a decimal fraction (0.5 or 0.5X magnification). For our calculations here, we are interested in expressing the reproduction ratio as a fraction or decimal. If we are using a 50mm lens and desire a reproduction ratio of 1:2, multiplying the focal length by the reproduction ratio gives us:

$$50mm \times \tfrac{1}{2} = 25mm$$

We would need 25mm of extension to produce a 1:2 reproduction ratio with our 50mm lens.

If you think it a little strange to establish a reproduction ratio by comparing the image size in inches to the object size in inches and then multiplying that figure by millimeters to get the needed extension, you are partially correct. But that same reproduction ratio can also be determined by comparing image and object sizes in millimeters—a reproduction ratio of 25:75 is the same as 1:3. A reproduction ratio is a ratio, not a quantity.

For the more mathematically inclined, the formula is $E = (M + 1)F$, where E is the extension needed, M is the magnification, and F is the focal length of the lens used. To find the magnification, just put an X after the reproduction ratio expressed as a fraction: a reproduction ratio of 1:2 is a $\frac{1}{2}$X magnification, a reproduction ratio of 3:1 is a 3X magnification. To take our previous example, using a 50mm lens and a 1:2 reproduction ratio:

$$E = (M + 1) F$$
$$E = (\tfrac{1}{2} + 1) \; 50mm$$
$$E = 1\tfrac{1}{2} \times 50mm$$
$$E = 75mm$$

Look strange? Especially since we have already determined that all the extension we need is 25mm to obtain a 1:2 reproduction ratio with a 50mm lens? This particular formula was indicated to give *total* lens to image distance, not just the extension needed in addition to the lens. So, if we now deduct the focal length of the lens from 75mm, we get the 25mm we came up with earlier. (Actually, the previous formula—$E = MF$—will give you the needed extension, while the longer formula gives the total extension, including the focal length of the lens. Gives you something to play with.) *These formulas assume the lens is focused on infinity.*

LENS-TO-SUBJECT DISTANCE

The working distance—the distance between the subject and the lens—can be calculated if we know the amount of extension in use or the magnification. Using the former, the formula is

$$U = \frac{FV}{V - F}$$

where U is the object distance (the distance between the subject and the lens), F is the focal length of the lens in use, and V is the image distance (the total extension—the focal length of the lens plus the extension used). If we use a 50mm lens and 50mm of extension, V adds up to 100mm. Using the formula:

$$U = \frac{F V}{V - F}$$
$$U = \frac{50mm \times 100mm}{100mm - 50mm}$$
$$U = \frac{5000mm}{50mm}$$
$$U = 100mm$$

It is a good thing this worked out this way, for we know that 50mm of extension with a 50mm lens will always give us a 1:1 reproduction ratio, and at a 1:1 reproduction ratio, the distance U and the distance V must be identical.

Using the magnification formula:

$$U = \frac{V}{M}$$

where U is the object distance, V is the image distance, and M is the magnification desired, and plugging in the same circumstances as above:

$$U = \frac{V}{M}$$
$$U = \frac{100mm}{1}$$
$$U = 100mm$$

It is always nice to have one's beliefs confirmed with nice, neat numbers. Should we be using a 50mm lens and 100mm of extension, V = 150 and U = 75mm. Plug these into the formulas and see if you come up with the right answer.

$$U = \frac{50 \times 150}{150 - 50}$$
$$U = \frac{7500}{100}$$
$$U = 75mm$$

Since 100mm of extension with a 50mm lens produces a 2X magnification,

$$U = \frac{150}{2}$$

$$U = 75mm$$

MAGNIFICATION

For simplicity in calculating other formulas, we have already found that magnification can be determined from the reproduction ratio. If we know the object size and the image size, we then already have the magnification expressed in the reproduction ratio. In fact, that is the first of several ways in which magnification can be expressed. The formula is:

$$M = \frac{i}{o}$$

where i is the image size and o is the object (subject) size. For instance, with an object size of four inches and an image size of one inch, the magnification is

$$M = \frac{1}{4}$$

which can be divided out and expressed as 0.25X magnification.

The total image distance divided by the object distance (V/U), the total extension and the focal length of the lens can also be used to compute magnification. The formula:

$$M = \frac{V - F}{F}$$

where V = the total extension (focal length of lens plus extension used). For example, using a 50mm

lens with 100mm of extension, we get:

$$M = \frac{150 - 50}{50}$$

$$M = \frac{100}{50}$$

$$M = 2$$

and indeed, as we have just seen, 100mm of extension with a 50mm lens produces a 2X magnification.

If we know U (the object distance—distance from lens to subject), we can work out magnification with the formula

$$M = \frac{F}{U - F}$$

Assuming an object distance of 75mm with a 50mm lens, we get:

$$M = \frac{50}{75 - 50}$$

$$M = \frac{50}{25}$$

$$M = 2$$

which, as we saw in the section on lens-to-subject distance, is correct.

Reproduction Ratio	Magnification	Extension w/ 50 mm lens	Exposure Factor	f-stop Increase
1:9	0.11X			
1:8	0.125X			
1:7	0.14X			
1:6	0.17X	1.56mm		
1:5	0.2X	3.13mm	1.44	
1:4	0.25X	6.25mm	1.5	½
1:3	0.33X	12.5mm	1.75	¾
1:2	0.5X	25mm	2.25	1
1:1	1X	50mm	4	2
1:0.5	2X	100mm	9	3
1:0.33	3X	150mm	16	4
1:0.25	4X	200mm	25	5
1:0.2	5X	250mm	36	6
1:0.17	6X	300mm	49	7
1:0.14	7X	350mm	64	8
1:0.125	8X	400mm	81	9
1:0.11	9X	450mm	100	10

EXPOSURE FACTOR AND APERTURE CONVERSION CHART

Magnification	Exposure Factor	Stop Correction
0.1	1.21	¼
0.2	1.44	½
0.3	1.69	¾
0.4	1.96	1
0.5	2.25	1¼
0.6	2.56	1¼
0.7	2.89	1½
0.8	3.24	1¾
0.9	3.61	1¾
1.0	4.00	2
1.2	4.84	2¼
1.4	5.76	2½
1.5	6.25	2¾
1.6	6.76	2¾
1.8	7.84	3
2.0	9.00	3¼
2.2	10.24	3¼
2.4	11.56	3½
2.5	12.25	3½
2.6	12.96	3¾
2.8	14.44	3¾
3.0	16.00	4
3.2	17.64	4¼
3.4	19.36	4¼
3.6	21.16	4½
3.8	23.04	4½
4	25.00	4¾

From Canon Guide Data for Close-up. Macrophotography and Photomicrography

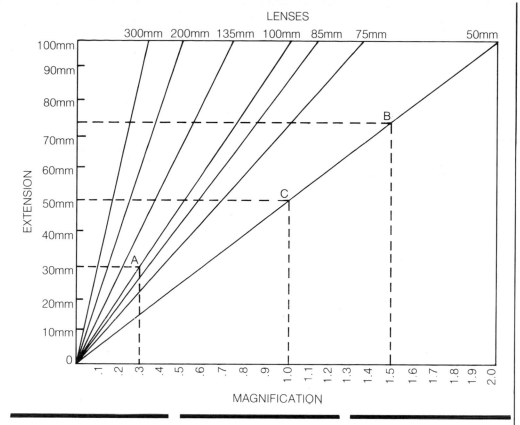

LENSES

EXTENSION

MAGNIFICATION

Lacking a behind-the-lens meter in your camera, you can determine the proper exposure using a hand-held meter and some arithmetic. A hand-held meter will give us a reading for a lens without extension. Once we know how much magnification we need, we can determine the exposure factor. The formula is:

$$ef = (M + 1)^2$$

Thus, if we have 2X magnification, this works out

$$ef = (2 + 1)^2$$
$$ef = (3)^2$$
$$ef = 9$$

The exposure factor with a 2X magnification is 9, which means 9 times as much light is needed, or about 3¼ f-stop correction. We learned how to determine magnification in the previous section, so we should have no trouble determining the exposure factor if we know the reproduction ratio, or the total extension used, or the distance between the subject and lens, for from any of these we can calculate the magnification to plug into this section's formula. □

MAGNIFICATION CHART

Extension, magnification and appropriate lens can be readily determined from this chart. Slanting lines represent lens focal lengths. Magnification figures are given along bottom of chart. Extension required is listed along side of chart.

To figure the extension needed for a given magnification, first determine the desired magnification. If you want to fill the narrow dimension of a 35mm frame with a subject three inches high, for example, you're talking about a 1:3 reproduction ratio, or a magnification of about .3X. Find the .3X magnification along the bottom of the chart, and move directly upward until you intersect the slanting line that represents the focal length of the lens you're using. Move horizontally from that point (marked A on the chart) to the edge of the

chart, and that will give you the required extension (30mm in this case, with a 100mm lens). A straightedge or ruler is helpful in reading the chart.

To determine the magnification with a given lens and amount of extension—let's say, 75mm of extension with a 50mm lens—find 75mm on the side of the chart, move horizontally across the chart

until you meet the 50mm lens line (point B), then read down from there to the bottom of the chart, and there you'll find the magnification (1.5X in this case).

To find the lens needed to produce a given magnification using a given amount of extension (say, a 1:1 copy with 50mm of extension tubes), just follow lines out from 50mm extension on the side of the chart and 1.0X magnification on the bottom of the chart, and where they intersect (point C) is the lens to use (in this case a 50mm lens—but you knew that from the extension tube chapter, didn't you—an amount of extension equal to the focal length of the lens you're using will produce a 1:1 reproduction ratio). If your two lines don't intersect on one of the lens lines, you'll need a lens focal length somewhere between the lens lines your lines intersect between.

All figures on this chart are based on the lens focused at infinity.

BLACK-AND-WHITE FILMS

EASTMAN FINE GRAIN RELEASE POSITIVE, 5302—Designed to produce positives (slides for projection) from black-and-white negatives. Best results are obtained with contact printing, emulsion to emulsion. Can be used with slide copier for enlargements.

KODAK DIRECT POSITIVE PANCHROMATIC, 5246—Reversal transparency film designed for producing original transparencies. Reversal occurs during chemical processing, eliminating negative step.

KODAK HIGH CONTRAST COPY, 5069—For copying only, provides a suitable film for copying existing prints, newspapers and similar material.

KODAK HIGH SPEED INFRARED, 2481—Negative film sensitive to infrared radiation, useful for special effects. Requires appropriate filter and infrared adjustment on camera focusing ring.

KODAK PANATOMIC-X— Extremely fine-grain, low-speed film whose high contrast can be modified with a compensating developer. Can be used for copy work with high-contrast developer.

KODAK PLUS-X PAN— Fine-grain, medium-speed film excellent for general work. Processing can be modified to produce different contrasts. Useful for producing negatives from color slides.

KODAK TRI-X—Moderately fine-grain, high-speed film for general usage. Useful in low light conditions or where lower contrast is desired.

KODAK ORTHO FILM, 6556—Extremely high-contrast film designed for line copy work in graphic arts. Used in slide copying for special effects, masks and similar applications. Process in Kodalith Super developer or in standard A and B litho developers.

COLOR FILMS

KODAK EKTACHROME INFRARED—Reversal film for transparencies produces false colors. Deep yellow filter required for exposure, but other filters can be used to produce different, dramatic results. Can be processed in E-4 chemistry.

KODAK EKTACHROME-X— Color slide film for general use. Moderate contrast makes it a good film for some slide copying applications.

KODAK EKTACHROME MS, 5256—Medium-speed color reversal film similar to Ektachrome-X. Available only in 100-foot rolls.

KODAK HIGH SPEED EKTACHROME—High-speed color film with moderate grain and contrast with slide copy applications. Available in daylight and tungsten versions.

KODAK EKTACHROME ER—5257 (Daylight) and 5258 (Tungsten) are high-speed color slide films with characteristics similar to High Speed Ektachrome. Available only in 100-foot roll lengths.

KODAK PHOTOMICROG-RAPHY, 2483—Extremely fine-grain, high-contrast color reversal film with high definition and good color saturation. Limited value in slide copying except for special effects, but excellent for outdoor work. Remarkable film for close-up work.

KODACHROMES—As a class, offer fine grain, slow to moderate speed, good saturation color slides. Good for general close-up work, of limited value for slide copying because of contrast.

KODAK EKTACHROME SLIDE DUPLICATING, 5038—For making duplicate slides from original Kodachrome and Ektachrome transparencies. Process in E-4 chemistry with shortened first developer time for optimum results. Color balancing is usually required. Excellent for slide copying. Available in 100-foot rolls.

EASTMAN EKTACHROME REVERSAL PRINT, 5386—For making duplicate color transparencies. Contact printing should make the most of this film. For general use I would recommend Slide Duplicating Film 5038 mentioned previously.